Magic Lantern Guides

Canon
Lenses

George Lepp / Joe Dickerson

Magic Lantern Guide to
Canon Lenses

A Laterna magica® book

First Edition 1995
Published in the United States of America by

Silver Pixel Press
Divison of The Saunders Group
21 Jet View Drive
Rochester, NY 14624

Written by George Lepp and Joe Dickerson
Edited by Steve Pollock

Layout: Buch and Grafik Design, Munich
Printed in Germany by Kösel GmbH, Kempten

ISBN 1-883403-16-2

®Laterna magica is a registered trademark of
Verlag Laterna magica GmbH & Co. KG, Munich, Germany
under license to The Saunders Group, Rochester, NY U.S.A.

*Product photos supplied by Canon USA, Canon GmbH,
Laterna magica, and the authors.*

Creative photography:
©1995 George Lepp
©1995 Joe Dickerson

®Canon and EOS are registered trademarks of Canon Japan

Contents

The Authors

George Lepp

George Lepp's interest in photography was sparked by his grammar school's newspaper advisor. The newspaper needed photographs, halftones and line negatives so George was burdened with a 4x5 Crown Graphic camera and taught some basic darkroom skills.

His interest waxed and waned throughout his high school and college days without progressing much beyond the hobby stage. Then George found himself in the Marine Corps working as an illustrator and, when his sketching skills proved not up to the task, he turned to photography as a way to express his artistic ideas. After serving in Hawaii and Vietnam, George returned to civilian life with a desire to explore the natural world with his newly found photographic skills (he had studied wildlife biology for three years prior to the Marine Corps).

At Brooks Institute of Photography in Santa Barbara, California George obtained a Bachelor's Degree with an emphasis in illustrative photography. He has since parlayed the combination of an artist's eye, a scientist's curiosity, and an understanding of photographic technique into an enviable career that encompasses nature and automotive photography, publishing, teaching and photographic equipment research and development.

Since its inception ten years ago George has been the field editor at *Outdoor Photographer* magazine. He conducts field trials of equipment and materials and writes a monthly column called "Tech Tips". He also publishes *The Natural Image,* a quarterly journal for nature photographers.

George currently has authored three books. *Bonneville Salt Flats* and *Vintage Car Racing* illustrate his ability to capture the speed and thrills of motor sport. His latest, *Beyond The Basics, Innovative Techniques for Nature Photographers*, is a Lepp seminar in book form designed for those who already know an f/stop from a gopher hole and want to put a fine edge on their photographic skills. George also produces a substantial number of

George Lepp and Joe Dickerson **Photo by Rich Hansen/Rich Images**

images for the stock photography market and is represented by Comstock in New York City.

George travels extensively each year teaching nature photography seminars and workshops ably assisted by his wife/business partner Arlie and his heir-apparent son, photographer, gofer, and tech person, Tory. On those rare occasions when the Lepps are all at home simultaneously they are joined by three poodles, Kernel, Truffles, and Apri, an African gray parrot named Bwana and, in the spring time, any number of crash-landed hummingbird chicks being nursed back to health by surrogate-mom Arlie and any one else she can con into "Hummer sitting".

Joseph Dickerson

Joe's interest in photography began when a high school friend who had his own darkroom introduced Joe to the magic of watching a print develop out in the tray. Even after nearly forty years, Joe's fascination with the photographic process has not diminished.

9

Throughout school and four years in the Air Force, photography remained a hobby while Joe pursued a career in music. Eventually, however, photography began to demand more time and Joe finally decided to pursue photography full time. After returning to college and majoring in photography, Joe worked a few years in a combination camera shop/commercial studio where he nurtured a lifelong interest in people photography.

With wife Sharon and their Saint Bernard, Quincy, Joe bought a small portrait studio on California's central coast in 1972. Although predominantly a portrait studio, the business became more diverse as they explored new markets for their work. During his tenure in the studio Joe met and was greatly influenced by David Brooks, then Senior Editor of *Petersen's Photographic* magazine. David's vast technical knowledge, "try anything" creativeness, and willingness to answer endless questions helped Joe through countless technical problems as well as the not infrequent shooter's block. Eventually, with David's encouragement, Joe became a contributing editor at *Petersen's Photographic* magazine and later at *Photo-Pro* magazine.

After nearly twelve years in the business, Sharon and Joe wanted to devote time to writing and teaching so the studio was sold. They both started writing and shooting for travel and bicycling publications while Joe taught part-time college classes and workshops. Today Sharon is writing full time and is very involved with women's Vietnam issues while Joe teaches full time and works on book and magazine projects.

Introduction

It is our opinion that the more familiar craftsmen are with their tools, the better they will be able to communicate through their medium. This book is, therefore, primarily about tools. Specifically it is about the lenses and optical accessories for the Canon EOS system. This book lists the complete specifications of Canon lenses and discusses the selection and use of lenses, filters, close-up devices, and other lens accessories presently available from Canon.

Secondly, we will talk about and demonstrate ways of applying these tools to a variety of subject matter, sharing what we have learned in an accumulated 50 plus years of professional shooting. As the applications of various lenses are discussed, you will find that this book has a unique advantage over the typical photo manual. Because we each make our living doing very different kinds of photography, we are able to present a much broader perspective than usual. While George might opt to use a long lens to give an intimate look into the natural history of an elusive creature, Joe may very well use that same lens as a means to eliminate background distractions or compress perspective when photographing a model. Throughout this book you will be hearing both of our reasons for selecting and using various Canon EF lenses. You will also find that we both like to discover techniques that utilize equipment in non-traditional ways to solve photographic problems or create a fresh look to what might otherwise be a cliché image.

Thirdly, we are both professional photographers, professional journalists and, through our workshops and seminars, professional educators. We feel strongly that this gives us an ethical obligation to see that the information in this book is as accurate and unbiased as we can possibly make it. This book was undertaken at the suggestion of Silver Pixel Press and was not funded by Canon (although they graciously provided us with tons of technical information and equipment support). So, although we are very grateful to the wonderful folks at Canon USA, we are not beholden to them. So, if we feel that a lens is too heavy or too slow for a certain application, we will let you know. However, due to our differing approaches we often use very different criteria for the selection of

lenses and accessories and, when our opinions or techniques differ, we will share both with you. Hence, you may rest assured that this book is not another glorified sales brochure.

Finally, our goal is to make this book instructional as well as technical. We not only explain various techniques and illustrate them through photographs but also include thorough information on how the photos were created, what equipment was used, plus the thought process behind the images.

So, read, enjoy and we'll see ya out there!!!

G.L. & J.D.

Brief History of Canon Cameras

Japan's first 35mm camera with a focal plane shutter, the Kwanon, was introduced in 1934. Like most Japanese cameras of the era, it was a copy of German optical and mechanical technology. In this case, the camera was patterned after the Leica model D. The reason for this blatant copying was simple, very few people in Japan could afford the highly prized Leica or Contax cameras of the day.

In 1934, the Leica model D with a 50mm f/3.5 lens cost a Japanese photographer a whopping 420 Yen. An incredible amount when you consider that the starting monthly salary for a university-educated bank employee was a not-so-whopping 70 Yen. German-engineered cameras represented state-of-the-art mechanics and optics but were affordable by only the wealthiest of the Japanese population.

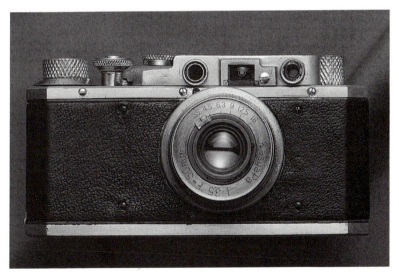

The Kwanon camera. Photo courtesy of Canon Camera Company, Inc. Tokyo; reprinted with permission, from the "Canon Compendium" by Bob Shell, published by Hove Books.

Canon engineers approached the development of a home-produced 35mm camera with religious fervor and, in fact, the name "Kwanon" refers to the Buddhist Goddess of Mercy. A short time later, the name was changed to Canon which means "precession" in Latin and which the researchers felt was more appropriate. Since that first humble Kwanon camera of 1934, Canon has produced over 65 million cameras.

Innovative Canon Lenses
Until the end of World War II Canon lenses were made with the technical assistance of another Japanese firm, but in 1946, Canon introduced its first independently manufactured lens, the Serenar 50mm f/3.5. Although they may have been late on the scene compared to the Germans, it didn't take Canon long to start making their mark in the optical community. In 1951, only five years after producing their very first lens Canon introduced the Serenar 50mm f/1.8 which offered better overall sharpness and contrast along with improved performance at the wide open aperture setting. This lens was a vast improvement over the standard Gauss-type lenses of the day which suffered from very poor performance when shooting wide open.

Another triumph came in 1961 with the introduction of the critically acclaimed 50mm f/0.95 lens. As the fastest lens ever produced, the 50mm f/.095 was prized by photojournalists. Today this amazing lens is highly-sought and prized by collectors worldwide.

In the 1960s, Canon's optical engineers were experimenting with Fluorite crystals for their unique optical properties. Unfortunately, these crystals exist in nature only in small pieces with too many impurities to be used in photographic lenses. Canon pioneered a technique of growing artificial crystals and, in 1969, introduced the FL-F 300mm f/5.6, the first lens in the world to incorporate a fluorite crystal. It was virtually free of the color aberrations normally found in long lenses and was considerably more compact than its contemporaries.

Most 35mm SLR cameras of the late 1960s had stopped-down metering. In order to take a light meter reading the lens had to be closed down to the taking aperture. Because this caused the viewfinder to darken when a small lens aperture was being used, it became impossible to focus and meter the exposure at the same

time. In 1971, Canon introduced the FD series of lenses which offered improved optics, easier operation with wide-open aperture metering, higher contrast, enhanced color balance and superior mechanics. This series of lenses included the FD 55mm f/1.2 AL which was the world's first SLR lens with an aspherical lens element. This lens virtually eliminated spherical aberrations and the loss of edge sharpness associated with them.

In 1973, Canon brought out two innovative lens designs that would each become a milestone in optical design. The TS 35mm f/2.8 SSC (the world's first Tilt-Shift lens for 35mm) allowed lens movements that previously were only available to view camera users. This lens would not only shift (actually it could shift horizontally or rise and fall vertically depending how it was oriented on the camera) but also allowed a swing or tilt movement to control the plane of focus. "SSC" stands for Super-Spectra Coating, a multi-layer coating process that increases light transmittance and color fidelity. The other lens, the FD 35-70 f/2.8-3.5 short zoom, was arguably the first zoom lens for 35mm cameras with results that rivaled fixed focal length lenses. This lens quickly attracted a large following among professional photographers. Today, the high demand for and impressive prices commanded by this lens on the used market attest to its outstanding quality.

Another Canon innovation came with a proprietary method for molding aspherical lens elements. (Ground and polished aspherical elements are very expensive to produce.) This facilitated the use of aspherical elements in relatively inexpensive lenses.

In March of 1987, Canon launched the future of Canon lenses with the production of the EF 50mm f/1.8 lens. This EF (electro focus) lens series incorporated a new lens mount that had photographers and the photographic press the world over shrieking in agony. This new mount was not compatible with previously produced Canon lenses so if you wanted autofocus you had to start over.

Initially this new EF mount seemed (to everyone but Canon) to be a really bad idea. This fact was not lost on the competition and many competitors' advertisements loudly acclaimed that any of "Brand X's" lenses would fit any camera they ever made. Well, Canon patiently sat back and took their lumps because they knew they would eventually be vindicated. Although changing the lens mount did mean that FD lenses would not fit EOS cameras, the

new mount made design improvements possible that the small physical diameter of the previous mount could not accommodate. Most notably, it allowed the autofocus mechanism to be incorporated into the lens rather than the camera body, which was determined by Canon to be a superior design.

In October of 1987, Canon introduced another "first." Their EF 300mm f/2.8L USM was the first lens with an Ultrasonic motor. The Ultrasonic motor features high torque for the ultimate in autofocusing performance. The new motor allows quicker focusing, quieter action and improved start and stop performance while eliminating the "searching" that plagued everyone's early autofocus lenses, a problem some manufacturers are still trying to overcome. In late 1989 Canon introduced three lenses that have become standard-issue for many a pro, the EF 20-35mm f/2.8L, EF 80-200 f/2.8L and the incredible EF 50mm f/1.0L USM. These high-speed lenses have set the industry standard for professional lenses in their focal lengths.

Today Canon makes over 50 lenses for the EOS system ranging from the rectilinear EF 14mm f/2.8L USM to the EF 1200mm f/5.6L USM (Yes, 1200mm, that's not a typo!) Many of these lenses are

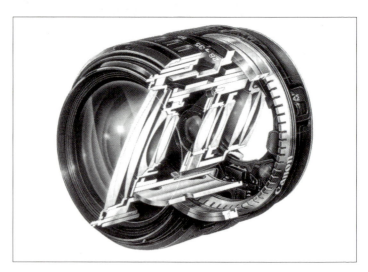

EF-lenses—a complex combination of optical, mechanical and electrical components comprise an integrated whole.

equipped with the latest Ultrasonic ring-type motors. In addition, the last few years have seen the introduction (thanks in part to the larger diameter lens mount) of many lenses with larger maximum apertures than previously available and zoom lenses that out perform many of the fixed focal length lenses of just a few years ago.

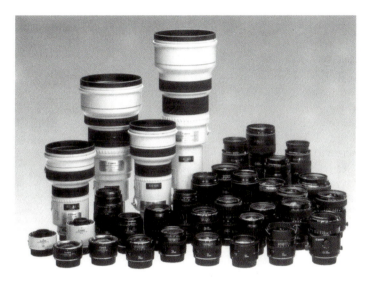

Canon EF lenses are available in an incredible range of focal lengths from ultra wide-angle to super telephoto.

Selecting the Right Lens

Focal Length and Angle of View

The focal length of a lens and its corresponding angle of view are two of the most important factors in determining how the subject will be depicted in a photograph.

The focal length of a lens is the distance from the optical center of the lens to the film plane with the lens focused at infinity. It is most commonly expressed in millimeters. To generalize, the shorter the focal length of the lens, the wider its angle of view. However, there is one exception in the Canon EF line. The EF 15mm f/2.8 Fish-eye lens has a 180° angle of view, while the 1mm shorter EF 14mm f/2.8L USM lens has only a 114° angle of view due to its rectilinear correction. An ultra wide-angle lens can include a great deal of visual information in a photo, sometimes more than is desirable.

A super telephoto lens on the other hand has an extremely narrow angle of view, approximately 4° for the EF 600mm f/4L USM lens. This allows the photographer to be more selective about what is in the frame. George refers to this technique as "Optical Extraction." An understanding of this concept is necessary if the photographer is to wield control over the final image. This relationship between lens focal length and angle of view can define a photographer's style.

Focal Length and Perspective

There has been a lot of misleading information written about the effect of focal length on perspective and we would like to try to set the record straight. As stated earlier, as the focal length increases, the size of the image gets bigger and the area included in the photograph (angle of view) is diminished. This relationship is directly proportional, so if you double the focal length of the lens, the subject will be twice as large in the photograph and conversely if the focal length is reduced by half, the subject size will be diminished by the same amount.

To illustrate all the focal lengths that we wanted and to allow us to work as quickly as possible (the weather wasn't cooperating and model Kimi Frederick was turning blue), we shot most of the images with zoom lenses. Specifically, we used the EF 20-35mm f/2.8L and the EF 35-350mm f/3.5-5.6L USM for focal lengths that fell within their combined ranges and the EF 300mm f/2.8L USM was used with the Extender EF 1.4x and Extender EF 2x to show the effects of 400mm (actually 420mm in this case) and 600mm focal lengths.

In the first series, the tripod-mounted camera stayed in the same location for each shot. The model sat on a sand dune with Morro Rock (called the Gibraltar of the Pacific) in the background. Notice that the perspective or relative size difference of the foreground subject (Kimi) and the background subject (Morro Rock) does not change as the focal length varies. As long as the camera position is unchanged foreground and background objects both change size proportionally.

Therefore, if the camera position remains the same, the perspective also remains constant. (Of course, fish-eye lenses will actually bend straight lines if they are not in the center of the frame so they are an exception to this rule.) The wives' tale of telephoto perspective proves to be a myth. In fact if you were to enlarge a section of the 20mm negative from this series to show the same image area as the 600mm negative, the perspective would be identical. Thus, the foreshortening that is often contributed to telephoto lenses is more a function of the camera position than the focal length.

However, if the camera position changes, as the focal length changes in order to maintain a constant subject size, then the foreground/background perspective will change dramatically as seen in the second series of photographs. To recap, the image size and angle of view are directly proportional to the focal length of the lens and the perspective or foreground/background relationship is altered by changing the camera to subject distance (fish-eye lenses excepted).

1. 15mm

2. 20mm

This series of eight photographs was shot to demonstrate what
happens to image size and angle of view as the focal length of the lens

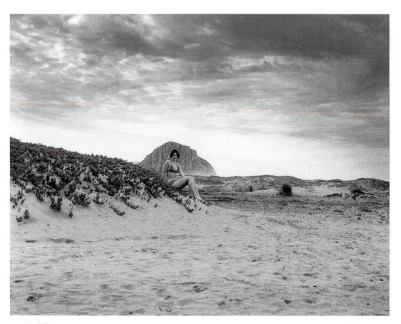

3. 35mm

 4. 50mm

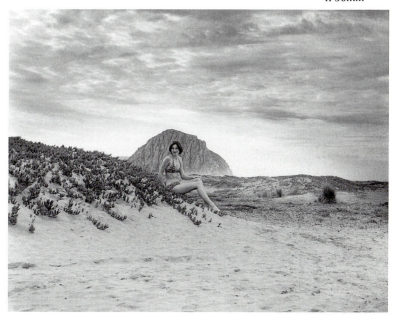

is changed while the camera position remains constant. Photos by the authors.

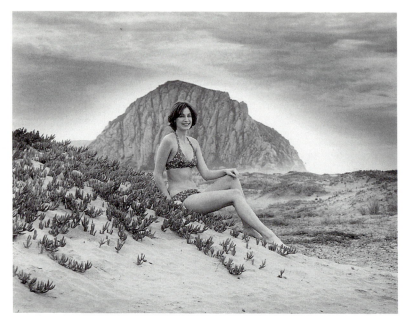

5. 100mm

6. 200mm

7. 420mm

8. 600mm

23

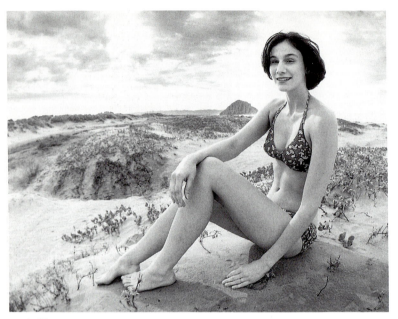

1. 15mm

2. 20mm

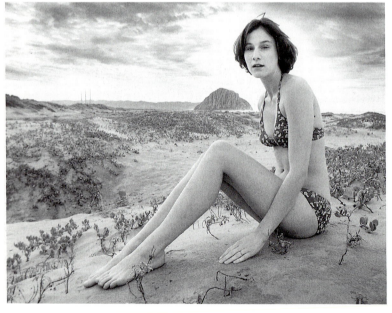

This series of eight pictures shows what happens to the relative size of objects in a scene if the focal length changes and the camera is reposi-

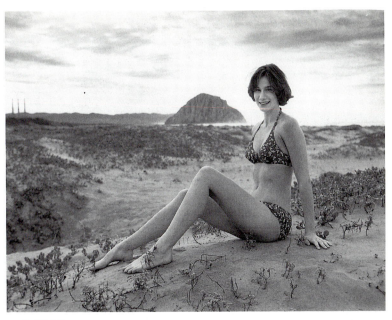

3. 35mm

4. 50mm

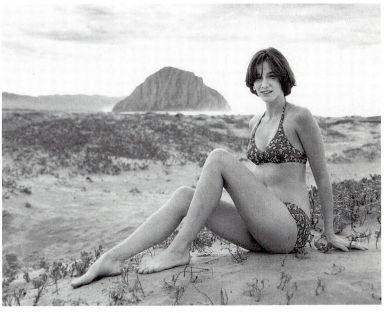

tioned so one object in the picture, the model in this case, maintains a consistant image size. Photos by the authors.

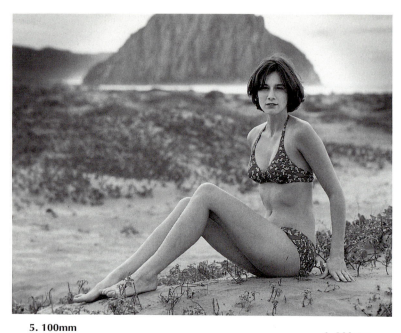

5. 100mm

6. 200mm

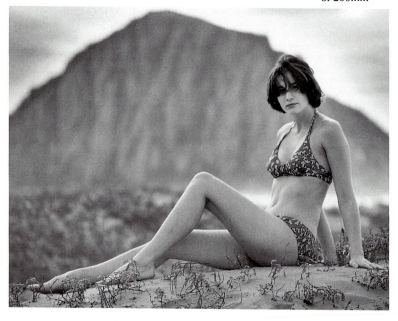

26

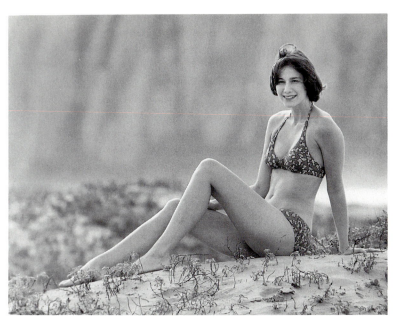

7. 420mm

8. 600mm

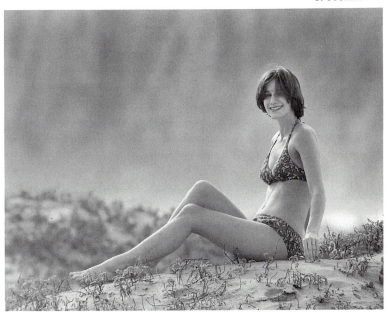

Canon Terminology

Aspherical Lens

A lens element having a freely-curved (non-spherical) surface is called aspherical. All lenses constructed of strictly spherical elements focus parallel light rays passing through the edge of the lens at a point closer to the lens than those passing through the center of the lens. This aberration exists in all spherical lenses to some degree and results in an overall soft, low-contrast image. Although stopping a lens down reduces this effect, aspherical lens elements are the only way to thoroughly compensate for it. Canon EF lenses make use of ground-and-polished or molded aspherical lens elements.

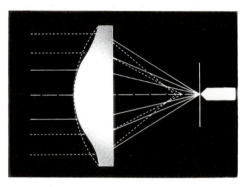

Aspherical lens elements have a non-spherical curvature which allows them to focus light rays striking all parts of the lens surface at a common plane.

Fluorite Glass

Fluorite has extremely low indexes of refraction and dispersion compared to optical glass. This makes it useful for reducing flare, increasing image sharpness and correcting chromatic aberration in lenses. In nature, fluorite exists only in crystals too small for photographic lenses but it has been used in microscope objectives since the late 1800s. In 1968, Canon perfected a process of growing artificial fluorite crystals large enough for photographic lenses, becoming the first camera manufacturer to utilize fluorite in photographic lenses.

Super-Spectra Coating

Every air-to-glass surface in a lens can reflect back approximately 5% of the light entering it. This causes a reduction in the amount of light transmitted by the lens and can also result in internal reflec-

tions or ghost images. EF lenses have a multi-layer Super-Spectra Coating (SSC) that reduces this light loss to 0.2 to 0.3%. It also helps the lens elements resist scratches.

UD Glass
UD or ultra-low dispersion glass is hybrid optical glass blended with fluorides. It produces lens elements with optical characteristics nearly as efficient as Fluorite but at a lower cost. Fluorite glass elements are specially useful in correcting chromatic aberrations in super-telephoto lenses but in other lens types it tends to be cost prohibitive. UD glass can be substituted for Fluorite in these applications at a considerable cost savings. Two UD elements give nearly the same correction as one Fluorite element.

Arc Form Drive (AFD)
The first type of motor designed by Canon for EOS lenses was the Arc Form Drive. It is a traditional small electrical motor but with its components arranged in an arc to fit in a lens barrel. Although it works very well, it is not as quiet or fast as the newer USM or Ultrasonic Motors.

Ultrasonic Motor (USM)
This focusing motor was invented by Canon and incorporated in many EF lenses since 1987 (the 300mm f/2.98 was the first). They are quicker and quieter than focusing motors previously used by Canon. There are currently four types of USM motors for use in EF lenses including three ring-types and the cylindrical Micromotor. This allows Canon to select the optimum motor type for the specific lens application. Canon states that eventually all their autofocus lenses will utilize USM focusing motors.

"L"-Series Lenses
"L" stands for Luxus or Luxury and is the designation Canon has given to its top-of-the-line lenses. Each of these lenses is designed to offer the best performance available in its class, regardless of cost. Canon uses various combinations of UD glass, Fluorite glass, and aspherical elements to achieve this. Although the "L"-series is the ultimate in lens technology, many of the standard Canon lenses perform nearly as well and produce satisfying results for most applications. In fact, we both use a mix of "L" and non-"L" lenses.

Canon EF Lens Components

Ring-type USM motor. This motor is the fastest and quietest, but is expensive to manufacture. This technology uses a high-frequency vibration to drive the lens.

The newer Micro-USM operates on the same principles, but is suited to mass production and is much less expensive. It is being used in place of AFD motors on all newer Canon EF lenses.

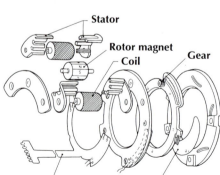

Stator

Rotor magnet

Coil

Gear

Flexible PC Board

Diaphragm blade

This diagram shows the construction of Canon's unique electrically-driven diaphragm mechanism, which uses stepper motors for precision and repeatability of aperture setting.

Building a Lens System

There are many theories on the best way to build a lens system that meets your photographic needs while maximizing cost vs. performance. Unfortunately, the most common approach is the "non-approach." This is often used by photographers who either aren't sure what kind of images they want to make, are too easily influenced by what the photo gurus write, or those who absolutely must have the newest lens regardless of its practicality.

In our workshops, we experience folks who apply one of these tactics and some who even combine all three to varying degrees. The problem with purchasing lenses this way is that you often wind up with lenses that someone else has decided were best for you without regard to your personal working style or choice of subject matter. For example, many photographers faced with a choice between the EF 50mm f/1.8 or the EF 50mm f/1.4 would opt for the f/1.4 lens because they perceive it to be a more "professional" lens. However, if a photographer shoots mostly in bright lighting conditions with the aperture set at f/5.6 or smaller it's doubtful that he or she will see any difference between the two lenses. Some old timers might argue that having a faster lens is advantageous since it provides a brighter viewfinder image with less depth of field, making it easier to focus. However, with today's reliable autofocus this is a moot point.

So how do you sort out all the hyperbole and make decisions based on facts and needs rather than myth? Well, you've already made a good start, you bought this book. As previously promised, we will make every effort to separate fact from fiction. We will also separate our own prejudices (we do have them!) from reality, or at the very least, try to let you know which is which.

There are two very intelligent strategies to help guarantee that your lens choices will be practical ones. Before we get to them however, we would like to clear up a misconception that has been around for as long as either of us can recall. Professional photographers do *not* buy every lens they desire simply because "lenses are tools" and we can "write them off." On the contrary, pros are probably more careful than the average amateur when choosing lenses because the choice of lens will directly impact their bottom line. A lens that doesn't do the job it was intended to do often means that we are unable to meet the needs of our client. In a

field where you are only as good as your last shoot, that can mean disaster.

The first lens choice strategy used by many pros is a mathematical one. Simply double or halve the focal length of the adjacent lens in the system. For example, if a pro shoots a lot with a 50mm lens, a 24mm lens would likely be a first wide-angle lens choice. The first longer lens would probably be in the 100mm range. These selections are of course tempered by differences in working style. Perhaps instead of choosing a 100mm lens for portraits, the photographer may prefer an 85mm lens which allows a shorter camera to subject distance, or a 100mm macro lens might be substituted for a standard 100mm lens, providing a lens with more versatility.

Not long ago the choice between fixed focal length lenses and zoom lenses hinged on whether or not you were willing to compromise lens speed and sharpness for convenience. Today the trade off (at least with high quality zoom lenses such as those in the Canon EF line) if it exists at all, is limited only to loss of lens speed. Both of us rely heavily on Canon EF zoom lenses and, except for some specialty lenses (high speed lenses for available light, macro lenses for close-up or copy work and tilt-shift lenses for architecture), we could use zoom lenses for nearly all our work.

A second approach to lens selection adopted by a lot of pros works well but requires a more thorough knowledge of the subjects you are likely to encounter. In this method, the photographer selects lenses to fit specific applications. For example, a photographer specializing in aerial photography has little need for wide-angle lenses and would more likely choose a high-quality, normal-to-telephoto zoom lens or several equivalent fixed focal length lenses for shooting oblique aerials and air-to-air shots. Then, the next purchase might be one ultra wide-angle lens for interior views of the aircraft. With this method, it often helps to talk to a few photographers that shoot the same kind of assignments but keep in mind that they may have prejudices and misconceptions of their own.

The mathematical approach usually results in a more versatile lens system capable of a wider range of assignments (albeit with some compromises). The subject-specific method achieves a system that is much less generalized but usually requires fewer lenses. Of course, these two methods of choosing lenses can be

combined to provide a very individualized system, and in fact, this is what most professional photographers do.

After you have settled on the focal length(s) you need, how do you narrow your choice to a specific lens? Here again, there are varying methods. One is to go to your local camera shop and try it out. Most shops will let you try the lens on your camera, shooting a few exposures in the store or outside on the sidewalk if you seem to be a serious customer. A word of caution however, don't take the lens for a "test drive" and then buy the lens from somewhere else if you value your relationship with your local dealer.

If you live in a large city you can probably find the lens you are interested in at a rental house. By renting it for a day or two you can use it in field conditions with real subjects and get a feel for how the lens performs. Speaking of renting, a lot of pros who find they only need certain exotic lenses occasionally never buy them at all, they just rent them when the need arises.

Another option is to attend a workshop sponsored by the manufacturer of the lens you're interested in or presented by a photographer who uses and promotes that brand. Just make sure the workshop features the kind of photography you want to do. A wedding workshop probably won't give you much chance to try out the latest 600mm f/4 and a workshop on bird photography might not be a good place to see the hottest new soft-focus portrait lens.

One word to bolster your self-confidence as you start building or adding to your lens system: When the authors were starting out, each major camera manufacturer had a few really great lenses which over the years have become classics and almost everybody seemed to make at least one or two real clunkers that were hardly better than Coke bottle bottoms! Today, if you stick with major brands, it is almost impossible to buy a lens that does not produce quality photographs. If you do get a lens from a major company that is not performing like it should, the manufacturer will undoubtedly bend over backward to make sure that you are happy.

Caring for Canon Lenses

OK! So you have your lens or lenses, now what? You want to keep them in pristine condition and functioning properly. So how do you protect your investment?

The first answer is obvious, keep your lenses in a good case! The best protection for your photo gear is one those hard-sided cases built like an armored car and lined with foam that keeps everything in its own snug little environment until it's time to shoot. Problem is, the case will weigh nearly as much as the gear that's in it. It will put a big ding in the trunk lid of your client's new BMW, and don't even think about shooting on the run, it's out of the question!

The best protection is a hard case and if you can afford it, do what some pros do. They store and transport their gear in a hard case and when they get to the location, they transfer only the stuff they need to a soft bag for the duration of the shoot and then it goes right back into the hard case. However, this technique is expensive. It's also redundant, so most of us will just go the soft-sided route and make darn sure that the bags we use provide the maximum protection possible. This translates into a weather-resistant bag with padded inserts (or dividers) with lenses carefully placed back in their own compartment as soon as they are no longer needed on the camera.

Although we both use backpacks and cases from several makers, one bag system we have both worked with for years and have found little to complain about is made by Domke®. Domke bags offer plenty of protection for your precious equipment and their versatility is all you could ask for. Designed by a professional photographer, the bags are, for all their ruggedness, lighter in weight than most of the other soft bags on the market.

We have both known photographers who can use a camera for years and, except for some scratches around the tripod socket, it looks nearly new. Likewise, we have also seen cameras barely out of the box that look like they are ready for the dust bin. Very often the difference is nothing more than organization.

Is your 300mm lens sitting on top of your extra film? Do you

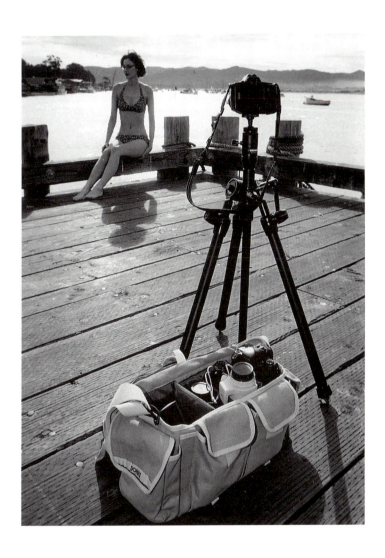

Don't skimp when purchasing a camera bag or a tripod. Choose a well-made bag, such as Joe's Domke F-1x bag, that holds all necessary equipment ready for action, and select a good, sturdy tripod that is not so big that you are tempted to leave it at home. Photo by Joseph Dickerson.

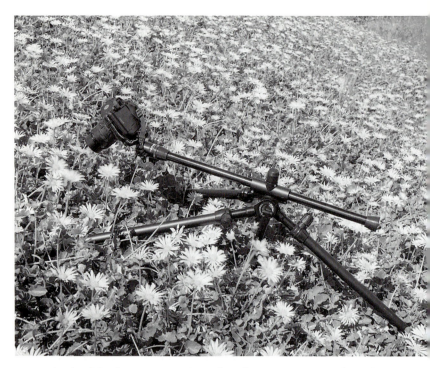

A tripod is almost a necessity rather than an accessory. The unique design of Benbo tripods allows them to position the camera easily and flexibly. Here the Benbo Trekker is shown getting the camera in close and low for photos of flowers. Photo by Joseph Dickerson.

have to take half your equipment out of your bag to get at your flash? Like your tripod, your camera bag should probably be one size bigger than you think you need. Not so much because your going to fill it up but because you need some room to find things. Of course, Murphy's Law will take over and eventually your gear will expand in volume to occupy all the available space.

An occasional evening spent with a soft, lint-free cleaning cloth, a soft brush, some cotton swabs, a bottle of alcohol (make a trip to the drugstore, not the liquor store, for denatured alcohol) and a can of compressed air going over your gear is time well-invested. For the most part, all you need do is use the air to blow dust and accumulated grime out of the cracks and crevices, and carefully

take an alcohol-soaked swab to anything really stubborn you encounter, like the residue of last ski season's fondue.

When you are using the compressed air, be very careful around the shutter because the blades or curtains could be knocked out of their track by a strong puff of air. (Some photographers prefer an ear syringe to canned air since the air velocity is more easily controlled.) Also, be very careful with the compressed air around the camera's mirror because the liquid propellant can blacken the mirror if it accidentally squirts onto it.

For cleaning lens, filter and viewfinder glass surfaces, use a high-quality lens tissue, a liquid lens cleaner and once again, the compressed air or ear syringe. George has been using the Luminex cleaning cloth from Falcon Products in place of lens tissue and lens cleaner and is very pleased with the results. Whichever you opt for, the idea is to get all and we mean all of the grit off the glass before you start to polish it. This is best accomplished with a puff of air and a clean soft brush or a dry swab made of several rolled-up lens tissues. However, lens brushes are hard to keep clean. Joe has had one for years that opens like a fountain pen but he hasn't seen this type in camera shops for a while so they may no longer be made. The pen style and those that close like a lipstick protect the brush from all the crud that collects in the bottom of a camera bag (have you ever really looked in there? Don't, it's not a pretty sight.)

After the grit is removed with a brush, use the cleaning cloth or put a few drops of the lens cleaner on several lens tissues you have wadded up and gently polish the glass. It is very important that you do not squirt the lens cleaner directly on the glass surface because it might flow into the lens and between the elements, causing them to de-laminate.

This periodic maintenance should be just that, periodic. If you shoot (as we do) around salt water and sea air a lot, it should be more frequent. In drier, less corrosive climates, it can be performed less often.

Other than monitoring battery condition and looking for the odd loose screw, there really isn't much else that we can or should do to keep our gear ready for the next shoot. However, photographers who fly a lot seem to have an increased problem with screws backing themselves out of critical holes at inopportune times. This is due to vibrations transmitted through the airframe to the camera

equipment. So, if you are racking up a lot of frequent flyer miles, you should check your gear more often than those of us who are more likely to travel by bicycle or kayak.

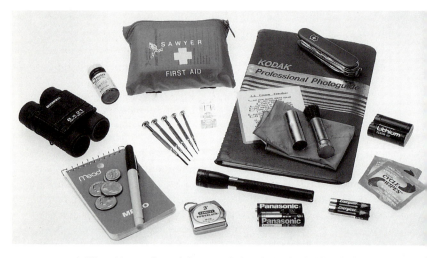

A partial list of items that might come in handy in the field include compact binoculars, a Swiss Army knife, a small screwdriver set, hand wipes, a tape measure, a note pad and pen, parking meter change, a pen light, film data sheets and a bubble level.

One last point on lens care, should you or should you not use a Skylight or UV filter on the lens to protect it? Well, here your authors disagree, sorta. Joe does (mostly) and George doesn't (mostly). Actually at times (in blowing sand or salt spray), George will protect his lens with a filter and, in situations where the extra glass is likely to cause lens flare, Joe takes the filter off.

One accessory neither of us is ever without is a proper lens hood. The universal "one hood fits all" jobs are certainly better than nothing. However, we both like the efficient hoods that Canon has designed for their lenses, so we have included the lens hood catalog number with each lens' specifications.

Pointing the camera up at coconut palms on the island of Molakai takes 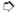 **creative advantage of the distortion of an EF 15mm f/2.8 Fish-eye lens. Photo by George Lepp.**

Fish-Eye and Ultra Wide-Angle Lenses

The human eye sees sharply across an angle-of-view of approximately 50 degrees, while the lenses in this section can take in as much as a whopping 180 degrees! That means they can render *everything* in front of your camera in sharp focus on the film.

These lenses allow us to bend or distort a scene to create an image that is a caricature of our subject, or to suggest a sweeping vista where in reality there is barely room to accommodate the camera.

Interior views of imposing Gothic cathedrals, exterior views of glass-and-chrome skyscrapers vaulting to the sky, vast fields of wild flowers recorded with clarity stretching practically from the front surface of the lens to infinity, environmental portraits with a "forced" perspective that suggests isolation or solitude, all of this and more is possible with these remarkable lenses.

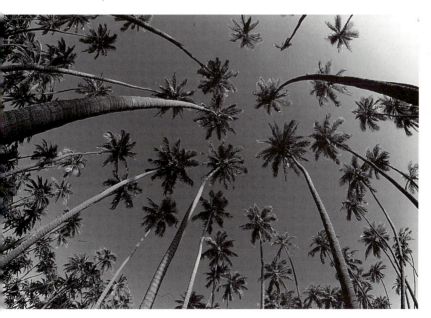

The ultra wide-angle lenses can give an awesome feeling of space by utilizing the convergence of parallel lines in the subject. Discovered during the Renaissance and used by artists to this day to create the illusion of depth in a two-dimensional medium, this "vanishing point" perspective can give a strong sense of distance in landscapes or spectacular stature to architectural subjects.

Often mistakenly thought to cause distortion by virtue of their short focal lengths, ultra wide-angle lenses actually record the subject without noticeable distortion if the film plane is kept parallel to the subject. Tilt the camera up or down, however, and the shot takes on an entirely different look. This convergence effect can be slight or pronounced, depending on the degree to which the camera is tilted and how close the camera is to the subject.

Fish-eye lenses create a very different look, as lines near the edge of the frame are noticeably curved, while lines in the center of the frame are recorded as straight. This fish-eye effect (actually a type of barrel distortion) gives a powerful feeling of expansiveness, and renders subjects close to the lens with a strongly exaggerated "look." Photographers who like this result call it perspective; those who don't name it distortion.

EF 14mm f/2.8L USM

Focus drive:	Ultrasonic
Angle of view:	114°
Lens construction:	13 elements in 10 groups
Minimum aperture:	f/22
Minimum focus distance:	0.8 ft. (0.25 m)
Length:	3-1/2 in. (89.0 mm)
Weight:	19.8 oz. (560 g)
Lens hood:	Built-in
Filter size:	Gelatin

The widest Canon lens available without the aforementioned fish-eye effect is the EF 14mm f/2.8L USM. Traditionally used to "get more in a photo" or to generate "back up" room, the unusual properties of this lens are employed by today's photographers to create images with a strikingly contemporary look.

One of these properties is an almost unbelievable depth of field. At an aperture setting of f/22, with the lens focused at the hyperfocal distance, the zone of sharpness ranges from nine inches to infinity. Architectural photographers will particularly appreciate the lack of distortion of this lens, and will find the extreme depth of field invaluable for near-far compositions.

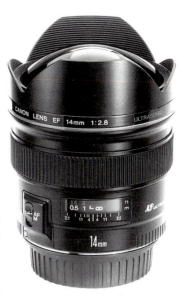

Although the EF 14mm f/2.8 USM lens is similar in size to the previous FD version, it contains an entirely new optical formula, including a large-aperture aspherical element that gives it a relatively large maximum aperture (f/2.8) with low flare and distortion characteristics.

EF 14mm f/2.8L USM lens

This compact lens has a built-in scalloped lens hood, and provision for using gelatin filters in the back. The extreme curve of the front element precludes using standard screw-on filters, and some photographers may lament the inability to use a polarizing filter. (Although a gelatin polarizer could theoretically be attached to the back of the lens, its use would be awkward at best.) However, with an angle-of-view this wide, it is nearly impossible to achieve even polarization of the sky, so the use of a polarizer would be problematic anyway.

The lens offers full-time manual focus, which allows you to override autofocus operation without changing any camera settings. The fast f/2.8 aperture is particularly helpful for manual focusing, as the generous depth of field at smaller lens openings can make focusing difficult. (Naturally, full autofocus operation is available as well.)

The EF 14mm f/2.8L USM lens provides a large maximum aperture and a 114° angle of view with relatively little distortion making it excellent for photographing architectural interiors. Photo by Joseph Dickerson.

EF 15mm f/2.8 Fish-eye

Focus drive:	Arc Form Drive
Angle of view:	180°
Lens construction:	8 elements in 7 groups
Minimum aperture:	f/22
Minimum focus distance:	0.7 ft. (0.2 m)
Length:	2-7/16 in. (62.2 mm)
Weight:	11.6 oz. (330 g)
Lens hood:	Built-in
Filter size:	Gelatin

Full-frame fish-eye lenses create a curved look that is similar to that of circular-image fish-eye lenses, except that the image fills the entire frame. This rounded appearance (barrel distortion) can make some subjects look quite ludicrous, but if the subject does not contain a lot of straight lines the effect becomes much less pronounced. Therefore, the lens can be used for scenic shots with minimal apparent distortion.

Once again, the relatively fast f/2.8 maximum aperture will be greatly appreciated if the lens is focused manually, as the extreme depth of field at smaller apertures tends to make focusing difficult.

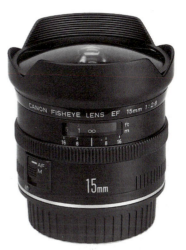

EF 15mm f/2.8 Fish-eye lens

The use of a fish-eye lens can quickly become clichéd, and many owners of these lenses find they soon grow tired of the predictably distorted images. George has found new life for the EF 15mm f/2.8 Fish-eye by using it for flower photography. In fact, it is nearly always included in his "field kit" when shooting wildflowers.

His approach is to set the lens to its closest focusing distance, stop it down to f/16 or f/22, and then position it underneath a reasonably tall cluster of flowers. As the stems of the plants are quite often naturally twisted, any distortion caused by the lens goes largely unnoticed. Meanwhile, the amazing depth of field produces sharp results from a couple of inches to a few feet from the camera.

George will often attempt to add an extra element to the photo by including the sun in the shot. With wide-angle lenses (including fish-eyes), the flare caused by the direct sun being included in the frame will appear as a star burst, adding an extra bit of interest and sparkle to the shot.

EF 20mm /2.8 USM

Focus drive:	Ultrasonic
Angle of view:	94°
Lens construction:	11 elements in 9 groups
Minimum aperture:	f/22
Minimum focus distance:	0.8 ft. (0.25 m)
Length:	3-1/16 in. (77.5 mm)
Weight:	14.2 oz. (405 g)
Lens hood:	EW-75
Filter size:	72mm

Only a few short years ago a 20mm lens was considered to be a radical wide angle. Today it is often the first lens to come out of the bag at the start of a shoot. Giving a full 94 degree angle of view but allowing the use of standard 72mm filters on the front of the lens (not possible with the EF 14mm f/2.8L USM or the EF 15mm f/2.8), the compact EF 20mm f/2.8 USM is an economical alternative to the EF 20-35mm f/2.8L zoom.

This lens also has some major advantages of its own: Near universal depth-of-field (1.5 ft to infinity at f/16), a non-revolving front element (made possible by rear-element focusing), true rectilinear rendering of architectural subjects, a very quick auto-focusing system (0.3 seconds from infinity to closest focus), and full-time manual focus. All of these combine to make this a very popular lens with photojournalists, commercial and architectural photographers, as well as those who specialize in scenic photography.

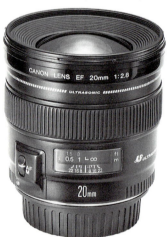

EF 20mm f/2.8 USM lens

The ability to utilize black-and-white contrast filters, special-effect filters (such as graduated neutral-density filters, star burst, or cross-screen types), and of course circular polariz-

ing filters allows the photographer to achieve visual effects easily, without resorting to rear-mounted gelatin or expensive, oversized front filters. As with any wide angle lens, the use of a polarizing filter on the EF 20mm f/2.8 USM requires careful scrutiny of the sky area for uneven polarizing effects.

The EF 20mm f/2.8 USM is a true rectilinear lens, and as such is especially well suited for architectural photography. Like any ultra-wide, however, objects at the extreme edge of the frame will display some "draw" —round objects will begin to take on an elliptical shape, being rendered as ovals rather than circles. This effect becomes less obvious as the object is placed closer toward the center of the frame.

The overall sharpness of this lens, coupled with its amazing depth of field, makes it a fine choice for scenic photographs that capture the sweep and expanse of an open plain. It allows you to create a near-far composition that brings the viewer into the scene in a way that a longer lens never could manage.

Another advantage of the EF 20mm f/2.8 USM lens is that it contains fewer lens elements than either of the EF 20-35mm zoom lenses. Therefore, fewer internal reflections (called flare) will be created when shooting directly into the sun. This can be a big plus to scenic and nature photographers who choose to include the sun in some shots, but want to avoid flare.

Wide-Angle Lenses

The lenses in this category tend to be overlooked in favor of the more versatile wide-angle zooms, or the exotic ultra wide-angle lenses discussed in the previous section. The moderate wide-angles have some unique characteristics, however, which ensure that they will never be replaced by their more glamorous cousins.

One of these advantages is compact size, particularly considering the relatively fast maximum apertures in this range. For the photographer who is concerned with packing maximum capability in the minimum possible space, these lenses are excellent choices. Backpackers, bicycle tourists, underwater photographers whose lenses must fit into water-tight housings, and travelers who simply don't want to be burdened with bulky lenses, will all appreciate the moderate wide-angle group. And despite their diminutive size, these lenses all have f/2.8 or f/2 maximum apertures that provide bright, easy-to-see viewfinder images.

Along with compact dimensions, these wide-angles offer the additional benefit of a relatively compact price. Although some of the zoom lenses that cover these focal lengths can carry breathtaking price tags, the fixed focal length lenses are more moderately priced, allowing photographers just starting out to build a photographic system that includes at least one wide-angle lens.

EF 24mm f/2.8

Focus drive:	Arc Form Drive
Angle of view:	84°
Lens construction:	10 elements in 10 groups
Minimum aperture:	f/22
Minimum focus distance:	0.8 ft. (0.25 m)
Length:	1-7/8 in. (48.5 mm)
Weight:	9.5 oz. (270 g)
Lens hood:	EW-60
Filter size:	58mm

This lens represents a complete redesign of the FD 24mm f/2.8, and although it is slightly larger and a bit heavier, it offers greater versatility and higher performance than the manual-focus version.

The EF 24mm f/2.8 has a rear-lens-group focusing system, like that of the EF 20mm f/2.8 USM, which not only corrects for aberrations but also eliminates astigmatism at close focusing distances. Equally important, the non-rotating front element facilitates the use of popular rectangular filters and filter holders, as well as polarizers. And the small front element allows the same 58mm filters that fit your standard lens to work with this wide-angle lens as well.

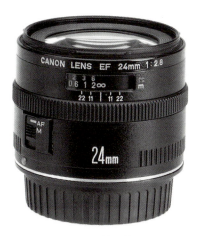

EF 24mm f/2.8 lens

Photographers who use a zoom lens that starts at 35mm (such as the EF 35-105mm f/4.5-5.6 USM or the EF 35-135mm f/4-5.6 USM) will find the EF 24mm f/2.8 lens a logical choice to expand their wide-angle capabilities. Travel photographers will particularly like this easily hand-holdable lens for shooting interiors or street scenes of exotic locales.

Further, photographers who select lenses by doubling or halving the focal lengths will appreciate the way this lens fits into a system built around the 50mm standard lens, as its 84-degree angle of view is almost exactly twice that of a 50mm.

EF 28mm f/2.8

Focus drive:	Arc Form Drive
Angle of view:	75°
Lens construction:	5 elements in 5 groups
Minimum aperture:	f/22
Minimum focus distance:	1.0 ft. (0.3 m)
Length:	1-11/16 in. (42.5 mm)
Weight:	6.5 oz. (185 g)
Lens hood:	EW-65
Filter size:	52mm

For years 28mm served as the standard wide-angle lens of 35mm photography. Today this focal length is not as popular with professionals, yet it still has a strong following among amateurs, who make it the most commonly purchased wide-angle lens.

While a 28mm lens can create "forced" perspective that is similar to an ultra wide-angle, and will yield nearly as much depth of field, it is far less likely to produce noticeable distortion if not held exactly level. Also, the amount of "draw" (elongation or curvature of shapes close to the edge of the frame) is minimal.

For wedding photographers and others who shoot a lot of group or candid images, the EF 28mm f/2.8 lens offers good depth of field even at moderate lens openings, plus the ability to get in close to the subject without distortion. This opportunity to shoot "up-close and personal" facilitates communication with your subjects, and allows you to be in the front row, eliminating the need to shoot around Aunt Millie and her Instamatic®!

Also, all Canon flash units will adequately cover the angle of view of this lens, even though some will need an auxiliary diffusion device to prevent vignetting.

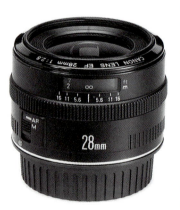

EF 28mm f/2.8

EF 35mm f/2

Focus drive:	Arc Form Drive
Angle of view:	63°
Lens construction:	7 elements in 5 groups
Minimum aperture:	f/22
Minimum focus distance:	0.8 ft. (0.25 m)
Length:	1-11/16 in. (42.5 mm)
Weight:	7.4 oz. (210 g)
Lens hood:	EW-65
Filter size:	52mm

Many photojournalists use a fast 35mm lens as a normal lens because it gives the combined advantages of a large lens opening, close minimum focusing distance, and easy handling. The newly designed EF 35mm f/2 was conceived as a fast, compact tool with highly-corrected optical characteristics. Ghosting and flare are all but eliminated, giving very high quality images with excellent contrast.

Although this lens utilizes a simple extension-type focusing system, the front element does not rotate, thus allowing easy use of screw-on filters and lens accessories. If any fault can be found with the EF 35mm f/2, it is the use of 52mm lens accessories rather than the 58mm size required by the majority of Canon EF models. Designing all EOS lenses with a standard 58mm front-thread size would have made things a bit more convenient for photographers in quickly changing situations. Ask anyone who has ever watched a beautiful sunset disappear while entertaining himself by scratching around in the bottom of a gadget bag looking for an elusive step-up ring! Believe us, we've both been there and had that pleasure.

Currently in the EOS system there are nine lenses that use 52mm filters and 14 that accept

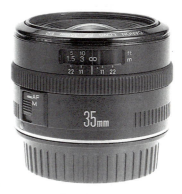

EF 35mm f/2.0 lens

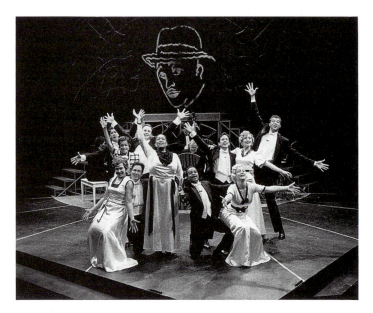

Using flash is not always desirable or permitted. When shooting in low light situations, choose a fast film and a fast lens. The EF 35mm f/2.0 provided ample coverage and speed for this photo of the entire cast from the finale of *Sophisticated Ladies* performed by the Pacific Conservatory of Performing Arts. Photo by Joseph Dickerson.

58mm, while the remainder use 72mm, 77mm, or 48mm drop-in sizes. We assume that lenses such as the EF 35mm f/2 were designed to accept 52mm filters to help keep their size to a minimum, but many photographers would be willing to accept a slightly larger lens barrel in order to avoid dealing with step-up rings or carrying more duplicate filters than necessary.

As previously mentioned, the 63-degree angle of view of the 35mm lens has made it the standard focal length for many photojournalists and nature photographers. However, in extremely low-light situations where flash is inappropriate, it is still often necessary to switch to a 50mm lens to get the extra speed of an f/1.4 lens. Many professionals are hoping that Canon will eventually see fit to add a 35mm f/1.4 lens to the EF line, to compete with those already available from several other manufacturers.

Standard Lenses

Today the accepted focal length for a standard lens (the authors and Canon prefer the term "standard" to "normal") is 50mm. This focal length gives an angle of view of almost 50 degrees, which corresponds to the concentrated area of human vision.

In theory, the standard focal length should be about 43mm, approximating the diagonal measurement of the 35mm negative. The discrepancy exists for a variety of sound reasons, including the need for easier focusing with the dim viewfinders of bygone days, and the fact that longer focal length lenses allowed the reflex mirror to clear the rear element of the lens without requiring any design compromises. In fact, lenses as long as 58mm were once provided as standard with some cameras.

Canon currently offers three standard lenses (a fourth optic, the EF 50mm f/2.5 Compact Macro, will be considered in the Macro lens section). They all have the same focal length (50mm) and angle of view (46 degrees), so there might not seem to be much difference between them. Not so!

One of these lenses is the fastest standard optic offered for an SLR camera; another is an economically priced lens with a moderate (by today's standards) f/1.8 aperture; and the newest, which will probably prove to be the most popular with professionals, has a speedy f/1.4 aperture.

In preparing this section, both of us realized that we only rarely use a 50mm lens. As we considered the reasons for this apparent oversight, it occurred to us that the main problem was the very normalcy of the focal length. After all, standard lenses are designed to give an angle of view and sense of perspective that closely approximate human vision. Therefore the resulting photographs tend to have a commonplace, routine look. Generally, images that capture a viewer's eye and imagination, by their very nature, will be out of the ordinary. To achieve visual impact, the perspective, camera angle, lens angle of view, or at times all three need to be surprising, rather than mundane.

Does this mean that standard lenses are ineffective? Should all professional photographers forsake 50mm lenses, leaving them to

be used only by amateurs to record family picnics? Once again, not so! After all, one of the most influential 35mm photographers of all time, Henri Cartier-Bresson, who said, "the camera is an extension of my eye," frequently employed a standard lens. So do many of today's eminent photographers.

We are simply suggesting that you not reach *automatically* for the 50mm lens when starting to work with a subject. Instead, decide how you want to depict the subject, then consider whether the standard lens will accomplish your goal.

In fact, because these lenses let you work from distances that create "normal" perspective, they can be the best choice when you are seeking to document a subject. Family gatherings, wedding or reunion groups, progress photographs of construction projects, or aerial photos of large-scale real estate developments are just some of the subjects that lend themselves to the normal perspective that a standard lens can provide. As many a wise photographic educator has advised, "start with a standard lens, and when you think you have done everything that the lens will do, then and only then try another focal length."

EF 50mm f/1.0L USM

Focus drive:	Ultrasonic
Angle of view:	46°
Lens construction:	11 elements in 9 groups
Minimum aperture:	f/16
Minimum focus distance:	2.0 ft. (0.6 m)
Length:	3-3/16 in. (81.5 mm)
Weight:	2.2 lb. (985 g)
Lens hood:	ES-79
Filter size:	72mm

If your idea of fun is to photograph black cats in a coal bin at midnight, if you own at least one stopwatch bought expressly for timing existing-light exposures, and if there never seems to be enough zeros on the end of your film's ISO number, then this lens was designed for you. With an amazing f/1.0 maximum aperture, it is the fastest optic available on an SLR. (However, the all-time speed record for a production lens goes to a non-SLR Canon optic,

the 50mm f/0.95 made for Canon rangefinder cameras of the 1960s.)

The EF 50mm f/1.0L is neither compact nor cheap, but if you want the ultimate standard lens, you may have just found it! The engineers at Canon used almost every trick in their book to make the EF 50mm f/1.0L lens a reality, and they sure did it right! This lens utilizes two ground and polished aspherical elements to control flare and give high-contrast images even with the aperture wide open. To control curvature of field (common with high-speed lenses), special high-refraction glass is used, complete with a newly developed multi-layer coating technique to ensure well-balanced color. A floating-element design also helps control curvature of field, as well as the spherical aberration that sometimes afflicts high-speed optics.

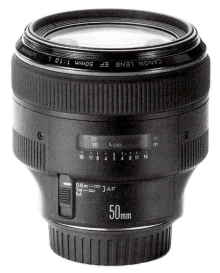

EF 50mm f/1.0L USM lens

This lens provides the useful option of selecting from two focusing ranges. One mode allows the lens to search the entire focusing range from 2 feet (0.6m) to infinity. If your subject definitely will be no closer than 3.28 feet (1 m) from the camera, it's better to select a reduced focusing range that increases the lens' AF speed.

EF 50mm f/1.4 USM

Focus drive:	Ultrasonic
Angle of view:	46°
Lens construction:	7 elements in 6 groups
Minimum aperture:	f/22
Minimum focus distance:	1.5 ft. (0.45 m)
Length:	2-15/16 in. (73.8 mm)
Weight:	10.1 oz. (290 g)
Lens hood:	ES-71
Filter size:	58mm

For those who require a lens with excellent low-light capabilities in a lighter and more compact package than the EF 50mm f/1.0L, Canon has recently introduced the EF 50mm f/1.4 USM. This lens is only one f/stop slower than the f/1.0, yet it weighs less than a third as much, and utilizes 58mm filters (the same as many other lenses in the EF line) rather than the larger and more expensive 72mm size.

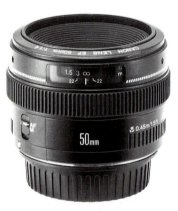

EF 50mm f/1.4 USM lens

The price differential between the two lenses is such that for the cost of an EF 50mm f/1.0L, you could buy the EF 50mm f/1.4 USM, toss in an EOS 1n body for good measure, and still have enough change left over for a weekend in the mountains. No wonder they sell more f/1.4s than f/1.0s!

The EF 50mm f/1.4 USM is similar in concept to the FD 50mm f/1.4 that preceded it. And even though the FD version was a benchmark for high-quality standard lenses, the new version has an improved optical formula that offers even better image performance. In addition, the Micro Ultrasonic motor allows fast and nearly silent AF operation, along with full-time manual focusing.

EF 50mm f/1.8 II

Focus drive:	Micromotor
Angle of view:	46°
Lens construction:	6 elements in 5 groups
Minimum aperture:	f/22
Minimum focus distance:	1.5 ft. (0.45 m)
Length:	1-5/8 in. (41.0 mm)
Weight:	4.6 oz. (130 g)
Lens hood:	ES-62
Filter size:	52mm

If you are into "petite," the EF 50mm f/1.8 II is the standard lens of choice. It is the shortest, lightest optic in its class, but don't let that fool you. This is a highly-corrected lens, giving well-balanced performance throughout its focusing range.

The f/1.8 aperture is slightly more than one-half stop slower than the EF 50mm f/1.4 USM, and certainly the latter gives better wide-open performance. If you don't need all that speed, however, the f/1.8 does just fine. When stopped down to mid-range apertures, it produces images that are virtually indistinguishable from those made at comparable apertures with the faster lens.

The focusing system utilizes a micromotor coupled to a simple cam-type drive, which gives rapid, quiet autofocus operation. Also, Canon has done everything possible to save weight and bulk, yet still provide good optical performance. One controversial weight-saving measure, however, is the plastic bayonet lens mount. It may well prove to be up to the task, but for those of us who are still getting used to plastic lens barrels and camera bodies, a plastic lens mount just doesn't inspire much confidence. Canon has several other lenses (mostly designed for the Rebel camera series) with plas-

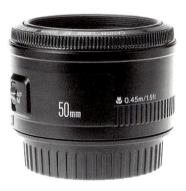

EF 50mm f/1.8 II lens
Photo by Joseph Dickerson.

55

tic mounts, but for professional use we are both more comfortable with traditional materials where the lens meets the body!

So which standard lens would we choose? Well, neither of us shoots often in situations where speed is of upmost concern, so we probably wouldn't spring for the EF 50mm f/1.0L USM. Besides, if we occasionally need a super-speed lens, we can always rent one. On a more practical level, the EF 50mm f/1.8 II is almost as sharp as the EF 50mm f/1.4 USM, when stopped down a bit. So logic might suggest buying the f/1.8 lens, and pocketing the three hundred or so bucks we'd save over the f/1.4 version.

Really, though, what's logic got to do with it? Like most photographers, we'd somehow justify the fast, sharp EF 50mm f/1.4 USM as being more "professional," or for some other flimsy reason. I guess we're only human after all!

Medium Telephoto Lenses

Canon currently offers fewer lenses in this category than were available in the FD system, but all the old favorites are present in newly updated versions. What's missing are mainly the slower, "economy" variants of the current selections. Also, the FD 85mm Soft Focus has been replaced by the EF 135mm Soft Focus.

All three of the current medium telephoto lenses are popular with photojournalists, because the longer-than-standard focal lengths and fast maximum apertures allow you to isolate subjects under a variety of lighting conditions. Portrait photographers also appreciate how the relatively wide lens openings facilitate selective-focus effects (the ability to record a sharply delineated subject against a soft blur of color and light).

Although these lenses duplicate focal lengths readily available in various Canon EF zoom lenses, they have two distinct advantages over zooms of the same focal length: size and speed. These lenses are quite compact and unobtrusive (except for the EF 85mm f/1.2L), making them ideal for candid portraits or fast-breaking news events, and their apertures are virtually as fast as standard lenses.

EF 85mm f/1.2L USM

Focus drive:	Ultrasonic
Angle of view:	28° 30′
Lens construction:	8 elements in 7 groups
Minimum aperture:	f/16
Minimum focus distance:	3.1 ft. (0.95 m)
Length:	3-5/16 in. (84.0 mm)
Weight:	2.3 lb. (1,025 g)
Lens hood:	ES-79
Filter size:	72mm

The EF 85mm f/1.2L offers a lot of speed in a hefty package that balances well on the camera. This lens is about 12 ounces (345g)

heavier than the FD version, and of course some of the additional weight is due to the Ultrasonic AF system. Speaking of focusing, the EF 85mm f/1.2L uses a front-group linear-extension system that enables the Ultrasonic motor to focus from 3.1 feet to infinity in only 1.2 seconds. That's fairly quick when you consider the size and weight of the front group, but downright sluggish when compared to the other lenses in this category. Incidentally, the front element does not rotate, so there is no need to reposition filters or optical accessories as the lens is focused.

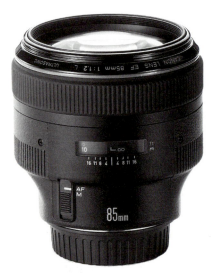

EF 85mm f/1.2L USM lens

Another plus is that the lens offers a high degree of optical correction. A large-diameter aspherical element used in conjunction with high-refraction glass corrects spherical aberrations, even with the aperture wide open. (A historical note: the FD 85mm f/1.2L was the first telephoto lens to be designed with an aspherical lens element.) Although the EF 85mm f/1.2L is a great picture-taker, it is expensive, and bulky enough that photographers with small hands may find it a bit much to hand-hold.

EF 85mm f/1.8 USM

Focus drive:	Ultrasonic
Angle of view:	28° 30′
Lens construction:	9 elements in 7 groups
Minimum aperture:	f/22
Minimum focus distance:	2.8 ft. (0.85 m)
Length:	2-15/16 in. (75.0 mm)
Weight:	14.9 oz. (425 g)
Lens hood:	ET-65II
Filter size:	58mm

At approximately one fourth the cost of its high-speed cousin, the EF 85mm f/1.8 USM is probably the medium telephoto lens of choice for most photographers. Despite its compact size and relatively low price tag, this completely redesigned EF lens actually improves upon the excellent performance of the FD 85mm f/1.8.

A rear-element Ultrasonic focusing system scoots from infinity to the minimum-focus distance in a snappy 0.3 seconds. The aberrations normally expected in a rear-element focusing design are corrected by two single-element lens groups, which also contribute greatly to the lens' outstanding sharpness and contrast.

As with other USM lenses, the EF 85mm f/1.8 can be focused manually at any time, and of course you can disengage the AF system entirely by switching to the manual-focus mode. Canon has again made the use of filters and other optical accessories more convenient by designing the lens with a non-rotating front element.

Among portrait photographers, there is some debate as to whether the 85mm or 100mm focal length is the best choice for close-up portraits.

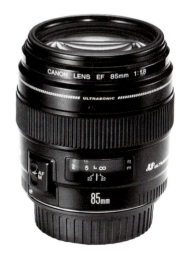

EF 85mm f/1.8 USM lens

If you make your living shooting portraits, you may want to own both focal lengths. To us, this seems to put too fine a point on the issue. If you go with the 85mm lens, you'll need to move the camera closer for extremely tight head shots which may cause some distortion or "drawing" of the subject's face. If you're shooting print film, the simple solution is to step back from the subject a little bit and crop the image during printing.

EF 100mm f/2.0 USM

Focus drive:	Ultrasonic
Angle of view:	24°
Lens construction:	8 elements in 5 groups
Minimum aperture:	f/22
Minimum focus distance:	2.9 ft. (0.9 m)
Length:	2-7/8 in. (73.5 mm)
Weight:	16.1 oz. (460 g)
Lens hood:	ET-65II
Filter size:	58mm

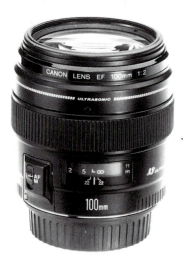

EF 100mm f/2.0 USM lens

Here's a pleasant conundrum: Canon started with the very successful FD 100mm f/2.0 lens, then gave it an improved optical formula for sharper, more contrasty images, added very rapid AF (with full-time manual override) plus internal focusing, kept the weight to within 10 ounces of the FD version, and introduced the new model at a price that is $45 *lower* than the original.

For photographers looking to shoot intimate candids in low light, or close-up studio and environmental portraits, this lens is probably the best compromise between the ultimate speed of the EF 85mm f/1.2L USM and the

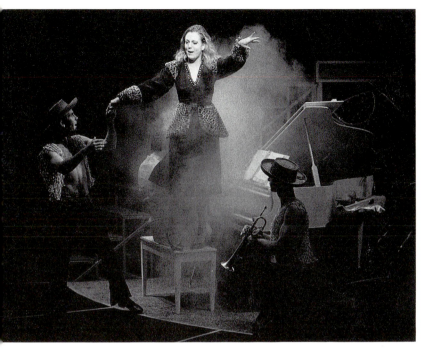

This photo from a production of *Sophisticated Ladies* was taken from several rows back in the audience with an EF 100mm f/2.0 USM lens. The focal length gives a tight composition, while the fast aperture allows the photographer to choose a shutter speed fast enough to stop the action. Photo by Joseph Dickerson.

economy of the EF 85mm f/1.8 USM. The EF 100mm f/2 USM is light enough to allow comfortable hand-held shooting for extended periods, and extremely sharp even when used wide open. The AF system is fast enough for action situations (0.4 seconds from infinity to 2.9 ft.), and once again, the front element does not rotate as the lens focuses. What more could you want?

Telephoto Lenses

Continuing where the medium telephoto group leaves off, the telephoto lenses offer increased reach, allowing the photographer to bring even more distant subjects up close. Each of the lenses in this section has its own special characteristics, making this a very interesting group, indeed.

As mentioned before, today's creative photographer doesn't employ telephoto lenses solely to pull distant subjects closer, but also as a tool to limit depth of field, control background rendition, and create a unique sense of perspective. In addition to these image-control capabilities, the lenses in this group are also fast enough to allow hand-held shooting in low-light situations.

EF 135mm f/2.8 Soft Focus

Focus drive:	Arc Form Drive
Angle of view:	18°
Lens construction:	7 elements in 6 groups
Minimum aperture:	f/32
Minimum focus distance:	4.3 ft. (1.3 m)
Length:	3-7/8 in. (98.4 mm)
Weight:	13.8 oz. (390 g)
Lens hood:	ET-62II
Filter size:	52mm

The Imagon™, Kodak Portrait™ and other classic soft-focus lenses took advantage of controlled spherical aberrations to achieve a beautiful "glow." The photographs created with these lenses often seemed as if they were illuminated from within. The EF 135mm f/2.8 Soft Focus lens uses this same method of image softening, yet retains the ability to shoot perfectly sharp images with normal contrast when desired.

This compact, lightweight lens is currently the only 135mm in the EOS line. It replaces several excellent FD optics that were considered among the best available at this focal length. Canon

has given the lens a relatively fast f/2.8 aperture (although an f/2.0 was available in the FD line), close focusing (a little closer than the FD versions), and has kept the size and weight within reason.

To achieve soft focus, you simply rotate the soft-focus control ring to the number one or number two setting (the zero setting indicates sharp focus). This moves an interior element to control the amount of spherical aberration. By varying the aperture and the soft-focus ring, you can achieve several degrees of softness. At apertures of f/5.6 or smaller, however, the soft-focus effect is virtually canceled out, regardless of setting.

One word of caution: The spherical aberration causes a noticeable focus shift as it is applied, so if you use manual

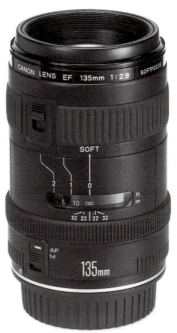

EF 135mm f/2.8 Soft Focus lens

focus, set the soft-focus effect and aperture first. If the camera is set in the AF mode, it will correct for the aberration automatically.

It would be easy to conclude that the EF 135mm f/2.8 is only for muted portraiture, but when the soft focus is not set the lens is tack sharp. George has used the EF 135mm f/2.8 Soft Focus lens extensively to create interesting flower and landscape images. Individual flowers can be isolated if an EF 25mm extension tube is added behind the lens, but remember that the aperture must be nearly wide open to achieve the soft-focus look. Groups of flowers are more difficult to shoot, as stopping down to increase depth of field negates the soft-focus feature. An alternative would be to add Canon Softmat filters, which give varying degrees of soft focus with any lens, even at small apertures.

Page 65:
This photo on the beach in Baja California, Mexico, was taken with the EF 14mm f/2.8L USM lens stopped down to f/22 and positioned as close as possible to have both the sand dollar and the horizon in focus. Photo by George Lepp.

Page 66, above:
The warm autumn colors of the Alaskan tundra are dulled by reflected light from the sky overhead. Notice the sky is mirrored in the beaver ponds. Photo by George Lepp.

Page 66, below:
The same scene is improved by the addition of a circular polarizing filter on the lens. The filter was rotated to give maximum saturation to the fall colors. Note that the ponds are now a bright, saturated shade of blue. Photo by George Lepp.

Page 67, above:
These two clown fish were photographed in an aquarium with the EF 50mm f/2.5 Compact Macro lens and flash. Photo by George Lepp.

Page 67, below:
For this shot of an earwig, the EF 100mm f/2.8 Macro lens was combined with the Canon Extender EF 2x to gain a higher magnification ratio. Photo by George Lepp.

Page 68, above and below:
The EF 80-200 f/2.8L zoom lens is an excellent choice for aerial photography. The lens is easy to handle, has a fast maximum aperture and the zoom range covers the focal lengths most often used for air-to-air and air-to-ground shooting. The photos show the same Rutan Long-EZ experimental aircraft with the lens at 80mm (top) and zoomed to 200mm (bottom). Photos by George Lepp.

Page 69, above:
A natural choice for sports is a long lens. In this case, the EF 500mm f/4.5L USM is used to get a tight shot of an Indy car at Laguna Seca Raceway. Although hardly compact, this lens handles well and allows the photographer to pan with the fast moving cars. Using a camera with predictive autofocus mode keeps everything sharp. Photo by Joseph Dickerson.

Page 69, below:
One way to introduce some excitement and motion to still photographs is to use a zoom lens with a slow shutter speed and zoom the lens in or out while the exposure is being made. For this shot, the EF 35-350 f/3.5-5.6 USM and a shutter speed of 1/8 second were used. Photo by Joseph Dickerson.

Page 70, above:
One of Canon's most incredible lenses shows its potential as a landscape lens. Mount McKinley in Denali National Park was photographed with the EF 35-350mm f/3.5-5.6L USM zoomed to 35mm. A circular polarizer and a graduated neutral density filter were used to saturate the colors and darken the sky. Photo by George Lepp.

Page70, below:
Zoom lenses offer greater flexibility in framing the subject as desired. This is a distinct advantage, especially when it is impossible to change the camera position. A good example is this aerial shot of an Alaskan glacier on the slopes of Mt. McKinley in Denali National Park. Photo by George Lepp.

Page 71, above:
The EF 300mm f/4L USM was combined with the Extender EF 1.4x to photograph this hang glider. This lens will autofocus with the Extender EF 1.4x but must be manually focused with the Extender EF 2x. Photo by Joseph Dickerson.

Page 71, below:
This photograph of the "Iron Ass" warbird on the taxiway illustrates the abundant sharpness that the EF lenses and EF Extenders possess. This shot was taken with the EF 300mm f/4L USM and the Extender EF 2x. Photo by Joseph Dickerson.

Page 72, above:
Sea stacks on the Mendocino Coast of California taken with the EF 35-105mm f/4.5-5.6. This compact, versatile lens is a natural for hikers, bicyclists, kayakers—anyone who can't carry a lot of equipment but wants to bring a camera. Photo by Joseph Dickerson.

Page 72, below:
These Pronghorn antelope browsing close to the road were shot with the EF 300mm f/4L USM and the Extender EF 1.4x. For support, the lens was positioned on the car's window sill with a bean bag underneath it. Photo by Joseph Dickerson.

The EF 135mm f/2.8 Soft Focus lens can be used to add a beautiful painterly feel to photographs of flowers. Photo by George Lepp.

EF 200mm f/1.8L USM

Focus drive:	Ultrasonic
Angle of view:	12°
Lens construction:	12 elements in 10 groups
Minimum aperture:	f/32
Minimum focus distance:	8.2 ft. (2.5 m)
Length:	8-3/16 in. (208 mm)
Weight:	6.6 lb. (3,000 g)
Lens hood:	ET-123
Filter size:	48mm Drop-in

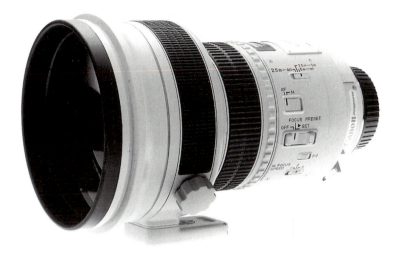

EF 200mm f/1.8L USM lens. Photo by Joseph Dickerson.

As you can tell by the specs, this is no compact lens. The EF 200mm f/1.8L USM and its FD predecessor are, however, the fastest lenses Canon (or anyone else) has ever offered at this focal length. Even if all this EF optic had to offer was an f/1.8 maximum aperture, it could reasonably justify a four-figure price tag. But Canon has loaded the lens with features that make it truly useful.

The EF 200mm f/1.8L benefits from very rapid Ultrasonic AF, utilizing internal focusing and offering full-time manual override. A preset-focus control allows the photographer to pre-focus on a part of the scene (for example the hoop at a basketball game). A slight rotation of the ring prompts the lens to return instantly to the preset distance, without having to "acquire" focus on a subject. So the lens will already be focused on the hoop as the photographer redirects the camera from a mid-court view.

Another nice feature is variable-speed manual focusing. The EF 200mm f/1.8L uses the Ultrasonic motor to accomplish manual focus, in this case giving the photographer a choice of three speed settings to fit the shooting situation. AF performance can also be adapted to the photographic situation by selecting from three focusing ranges: 8.2 feet (2.5 m) to infinity; 16.4 feet (5 m) to infinity; or 8.2 feet (2.5 m) to 16.4 feet (5 m).

Color fringing (common with ultra-fast long lenses) is controlled by the use of three ultra-low dispersion (UD) glass elements, resulting in sharp, contrasty images even when shooting wide open.

EF 200mm f/2.8L USM

Focus drive:	Ultrasonic
Angle of view:	12°
Lens construction:	9 elements in 7 groups
Minimum aperture:	f/32
Minimum focus distance:	4.9 ft. (1.5 m)
Length:	5-3/8 in. (136.2 mm)
Weight:	1.7 lb. (790 g)
Lens hood:	Built-In
Filter size:	72mm

Like its much costlier f/1.8 sibling, the EF 200mm f/2.8L USM offers more than just a fast maximum aperture. A redesigned version of the popular FD lens, the new model has been augmented

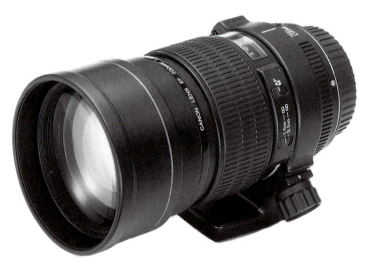

EF 200mm f/2.8L USM lens

optically by the addition of two UD glass elements. This improves performance, especially wide-open, in a package that is only 1/8 inch (2.2 mm) longer and barely 2 ounces (55 g) heavier than its predecessor.

Add rapid Ultrasonic focusing with two user-selectable focusing ranges – 4.9 feet (1.5 m) to infinity or 11.6 feet (3.5 m) to infinity – and you have a lens that proves to be a real winner. Internal focusing keeps the lens well-balanced on the camera throughout the distance range, and adds the benefit of a non-revolving front element.

Combining the EF 200mm f/2.8L USM with the Extender EF 2x is one method that wildlife photographers can use to obtain an excellent 400mm f/5.6 lens. This combo will give professional-quality results with the added advantages of compactness, light weight, and a very close focusing distance of 4.9 feet (1.5 m), all at a cost considerably lower than some of the bigger lenses. Plus, you will still have the advantages of a fast 200mm lens when needed. If you also own the Extender EF 1.4x, you can combine it with the EF 200mm f/2.8L USM to achieve a 280mm f/4 lens. Not a bad deal!

Super Telephoto Lenses

Everyone who shoots nature subjects or action sports, or simply attends major sporting events, is familiar with super telephoto lenses. Although they are expensive, these lenses are often the only way to get the decisive shot that tells the full story by capturing the subject's reactions or emotions. If the EF 200mm f/2.8L USM will fill the frame with a particular subject from 60 feet away, the EF 300mm f/2.8L USM gives the same image size at 90 feet, the EF 600mm f/4L USM at 180 feet, and the EF 1200mm f/5.6L USM at an awesome 360 feet.

This marmot was photographed using the EF 300mm f/2.8L USM with the Extender EF 2x to achieve a focal length of 600mm with a maximum effective aperture of f/5.6. The combination is only one stop slower but considerably more compact than the EF 600mm f/4L and still allows autofocusing. Photo by George Lepp.

In recent years, a growing number of pros have abandoned other camera systems to adopt the Canon EOS line; for a lot of them the deciding factor has been the quality and features of the Canon super telephoto lenses. All of the Canon super telephotos offer internal or rear-element focusing, so the lenses don't expand in length as they are focused. As a result, they stay balanced in the hand or on the tripod. All have Ultrasonic focusing motors that give extremely fast, precise autofocusing without having to "search" for focus. In fact, each lens can focus from the minimum distance to infinity in under a second, with the fastest ones covering the distance in well under half a second!

However, the lenses in this class require the photographer to exercise the utmost care when shooting. Their long focal lengths magnify not only the subject, but also any camera movement or shake. This makes it difficult to get sharp results unless a very secure camera support is used, such as a tripod or monopod. Both of us have encountered workshop participants who blamed fuzzy images on poor lens quality, but then admitted to hand-holding telephoto lenses at slow shutter speeds. It is actually rather simple to differentiate between camera shake and poor lens quality: using a high-quality magnifying loupe, examine the print or slide. If the highlights seem to be elongated or appear as streaks rather than discrete points of light, the camera moved during the exposure.

Neither of us hand-hold a camera (regardless of focal length used) unless it is absolutely necessary. Camera support is usually a solid tripod, such as models from Benbo, Bogen, and Gitzo. In fact, Joe has a Gitzo tripod fitted with a Bogen head, which he insists on calling a Bozo!

If the use of a tripod is not possible, we substitute a heavy-duty monopod. When shooting from the car, a window mount or bean-bag on the window sill under the lens is used. If none of these choices is possible, we lean against a tree, or set the camera on a rolled-up jacket, back pack, camera bag, or anything else that will steady the camera and dampen out vibrations. If the only option is hand-holding, the rule-of-thumb is to shoot with a shutter speed that is at least equal to the focal length of the lens in use. For example, a 500mm lens requires a shutter speed of at least 1/500 second. A word of warning—this rule tends to be optimistic, and for a lot of photographers setting a shutter speed that is one-half or one stop faster will give better results.

If you are in doubt about your hand-holding abilities, a simple test can help determine the slowest shutter speeds you can use safely. It takes only a few frames on a roll of film. Set up a test target with lots of detail (a sheet of newspaper tacked to the garage door will suffice), and shoot with the lens or lenses in question at progressively slower shutter speeds, keeping an accurate record of each shot. After the film is processed, inspect the images with a good quality loupe. Once you have identified the slowest shutter speeds that you can successfully hand-hold without any loss of sharpness, you may still want to add a measure of safety by moving up a step or two.

EF 300mm f/2.8L USM

Focus drive:	Ultrasonic
Angle of view:	8° 15′
Lens construction:	9 elements in 7 groups
Minimum aperture:	f/32
Minimum focus distance:	9.8 ft. (3.0 m)
Length:	9-9/16 in. (253 mm)
Weight:	6.3 lb. (2,855 g)
Lens hood:	ET-118
Filter size:	48mm Drop-in

The EF 300mm f/2.8L USM was the first of the Canon EOS super telephotos, and it has become the flagship of the fleet. The lens uses fluorite and low-dispersion UD glass to eliminate axial chromatic aberration throughout the aperture range. It features fast Ultrasonic focusing (0.42 seconds from closest distance to infinity) and offers preset focusing operation.

The preset AF feature was mentioned in the section covering the EF 200mm f/1.8 USM, but since it is included on all of the super telephotos (except the EF 300mm f/4L USM), a more in-depth look might be in order. The Focus Preset Switch has three settings: off, focus preset, and set. To select and set a preset-focusing distance the following sequence is followed.

First you slide the Signal Selector switch to the right. This turns on an audible signal that will "beep" to let you know when the lens has focused at the predetermined distance. Next you focus

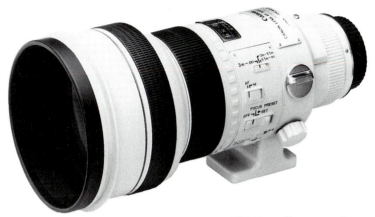

EF 300mm f/2.8L USM lens

on the desired point, remove your finger from the shutter button, and move the Focus Preset button to the set position. The audible signal will beep to let you know that the lens has memorized the distance. Now focus and shoot as usual. When something happens at the preset distance, a slight turn of the Reading Ring (the white knurled ring located between the focusing ring and the focusing scale) automatically focuses the lens to the preset distance.

On all the super telephoto lenses (again except for the EF 300mm f/4L), the Ultrasonic motor is utilized to achieve manual focus at your choice of three speeds. With the 300mm f/2.8L, the photographer can also select from three autofocusing ranges: 9.8 feet (3.0 m) to infinity; 21.3 feet (6.5 m) to infinity; or 9.8 feet (3.0 m) to 21.3 feet (6.5 m).

One of the most important benefits of the EF 300mm f/2.8L USM is its compatibility with the Extender EF 1.4x and the Extender EF 2x. Coupled with the 2x tele-extender, the lens becomes an extremely compact and sharp, autofocusing 600mm f/5.6. With the Extender EF 1.4x attached, you get a fast 420mm f/4 telephoto, with the same great sharpness and ease of handling. An added bonus is that the minimum-focus distance of 9.8 feet (3.0 m) is maintained with either extender. This combination of lens and tele-extenders makes the EF 300mm f/2.8L USM one of the most versatile lenses available for nature photography.

The EF 300mm f/2.8L USM lens was used to isolate a soloist during a performance of *Sophisticated Ladies*. The camera was supported with a monopod to ensure this close-up portrait was sharp. Photo by Joseph Dickerson.

EF 300mm f/4L USM

Focus drive:	Ultrasonic
Angle of view:	8° 15′
Lens construction:	9 elements in 7 groups
Minimum aperture:	f/32
Minimum focus distance:	8.2 ft. (2.5 m)
Length:	8-3/8 in. (213.5 mm)
Weight:	2.9 lb. (1,300 g)
Lens hood:	Built-In
Filter size:	77mm

Less weight, a lot less bulk, the ability to accept standard screw-on lens accessories, and a minimum-focusing distance over a foot closer than the EF 300mm f/2.8L USM, have all made the EF 300mm f/4L USM a very popular lens. At a street price less than one-third that of its one-stop-faster sibling, the EF 300mm f/4L USM tends to be unfairly regarded as an entry-level lens. Actually, UD glass elements are used in both the front and rear groups to correct residual axial chromatic aberration, while a unique design enables the various lens groups to mutually cancel out their respective aberrations. The result is highly-corrected, high-quality images with excellent contrast, even wide open.

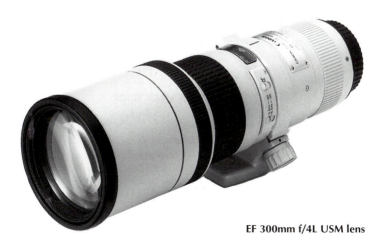

EF 300mm f/4L USM lens

Canon has paid special attention to the manual-focusing aspect of this lens, giving it the same silky feel as the older FD version. The autofocusing range can be set from either 8.2 feet (2.5 m) to infinity or 19.7 feet (6.0 m) to infinity, giving closer focusing when needed, or quicker focusing with distant subjects.

The EF 300mm f/4L USM was combined with the Extender EF 1.4x for this photograph of an elephant seal with her newly born calf. The 420mm effective focal length allowed the photographer to create an intimate image without harrassing the animal and/or endangering himself. Photo Joseph Dickerson.

The lens is fully compatible with the Extender EF 1.4x and Extender EF 2x, although manual focusing must be employed with the latter. Images are extremely crisp and contrasty with either extender, and of course the minimum-focusing distance is maintained. Another nice touch is that the tripod mounting collar also fits the EF 200mm f/2.8L USM and the EF 80-200 f/2.8L lenses.

EF 400mm f/2.8L USM

Focus drive:	Ultrasonic
Angle of view:	6° 10'
Lens construction:	11 elements in 9 groups
Minimum aperture:	f/32
Minimum focus distance:	13.2 ft. (4.0 m)
Length:	13-3/4 in. (348 mm)
Weight:	13.5 lb. (6,100 g)
Lens hood:	ET-161B
Filter size:	48mm Drop-in

When introduced in 1991, this was the only 400mm autofocusing optic with an aperture of f/2.8. Today there are others available, but they still take a back seat to the AF speed of the EF 400mm f/2.8L USM. In fact, the lens focuses from its minimum distance to infinity in only 0.7 seconds. It also offers full-time, variable-speed manual focusing, plus the same preset-focusing operation discussed earlier. The AF range may be set to either 13 feet (4.0 m) to infinity, 31 feet (9.5 m) to infinity, or 13 feet (4.0 m) to 31 feet (9.5 m).

Why own a lens this long with an f/2.8 aperture? The obvious answer is for indoor action sports (basketball, hockey, etc.) or outdoor sports at night (football, baseball, etc.). However, a lot of

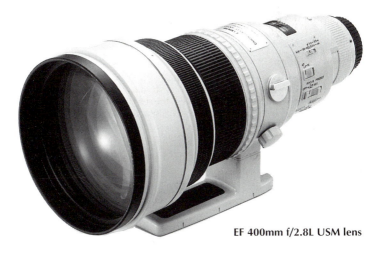

EF 400mm f/2.8L USM lens

professionals prefer this lens not for what it will do to the subject, but for how it renders the background. With a slower 400mm lens used wide open the background is only partially out of focus, while the EF 400mm f/2.8L USM renders the background completely out of focus to isolate the subject against a soft blur of color and light.

In 1986, Joe covered the transcontinental bicycle tour "Race Across America" with the FD version of the EF 400mm f/2.8L USM (the two lenses are optically identical). He was astounded at the way the lens made the individual cyclists appear to "pop" out of the cluttered and distracting backgrounds in a way that shorter or slower lenses couldn't duplicate. Its fast aperture also allows the 400mm f/2.8L to autofocus with either of the EF Extenders, resulting in a 560mm f/4 lens (focusing almost 7 feet closer than the EF 600mm f/4L USM) or an extremely close-focusing 800mm f/5.6 lens.

EF 400mm f/5.6L USM

Focus drive:	Ultrasonic
Angle of view:	6° 10′
Lens construction:	7 elements in 6 groups
Minimum aperture:	f/32
Minimum focus distance:	11.5 ft. (3.5 m)
Length:	10-1/16 in. (256 mm)
Weight:	2.7 lb. (1,250 g)
Lens hood:	Built-in
Filter size:	77mm

Introduced in 1993, the EF 400mm f/5.6L USM enables photographers to choose from two different maximum apertures (and price ranges) in the popular 400mm focal length. But don't think for a moment that this lens is just a poor man's version of the EF 400mm f/2.8L USM. The "economy" model offers features the f/2.8 version can't touch.

Start with a brand new glass called Super UD. It usually takes two UD elements to provide the amount of correction obtainable from one fluorite element, but one Super UD element can perform as well as fluorite. Because of this new glass (and other improvements), the EF 400mm f/5.6L USM performs equally well

at all focusing distances, and actually out-performs the older FD 400mm f/4.5 lens by a considerable margin.

Along with improved optical quality, it is also loaded with beneficial features such as a built-in hood; two focusing rings allow the lens to be focused manually with the built-in lens hood retracted; full-time manual focus; and a choice of AF ranges, either 11.5 feet (3.5 m) to infinity or 29 feet (8.8 m) to infinity. In addition, the lens accepts standard 77mm lens accessories and the tripod-mounting collar can be removed if desired.

The 400mm f/5.6L's performance is outstanding with the Extender EF 1.4x (making a 560mm f/8) or Extender EF 2x (for an 800mm f/11). However, autofocus is not available with either extender.

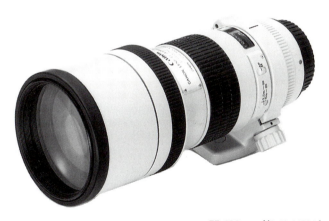

EF 400mm f/5.6L USM lens

EF 500mm f/4.5L USM

Focus drive:	Ultrasonic
Angle of view:	5°
Lens construction:	7 elements in 6 groups
Minimum aperture:	f/32
Minimum focus distance:	16.4 ft. (5.0 m)
Length:	15-3/8 in. (390 mm)
Weight:	6.6 lb. (3,000 g)
Lens hood:	ET-123B
Filter size:	48mm Drop-in

Although this lens is not small by any standard, its weight is reasonable (half that of either the EF 400mm f/2.8L USM or the EF 600mm f/4L USM), and it handles quite easily for this class of lens. When the EF 500mm f/4.5L USM was introduced in 1992, Canon's press release claimed that the lens was small enough and light enough for hand-holdable shooting. That's probably true, but if you're going to be shooting for longer than three minutes you're going to want some support under this thing! As previously mentioned, the authors try to avoid hand-holding a camera, regardless of lens focal length. It's not that we're both wimps or caffeine addicts with the jitters. We have simply discovered that the per-

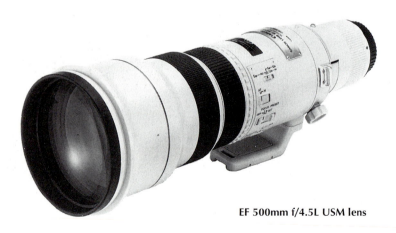

EF 500mm f/4.5L USM lens

centage of sharp photographs goes up in direct proportion to the stability of the camera support. This is known as Lepp's first (and thankfully, last) law of photography.

Like other lenses in the super tele group, the EF 500mm f/4.5L USM offers full-time manual focus which utilizes the AF motor for a choice of "normal", "half-speed", and "double-speed" operation. Very quick autofocusing covers the user-selected range of 16.4 feet (5 m) to infinity, 39.4 feet (12 m) to infinity, or 16.4 feet (5 m) to 39.4 feet (12 m).

One disappointing aspect of this lens is that it will not autofocus with the Extender EF 1.4x, as the resulting f/6.3 maximum aperture is just outside the acceptable range for AF operation. (This requirement is discussed in greater detail in the section on tele-extenders.)

This vintage 1966 AC Cobra 427 was captured at Sears Point raceway with the EF 500mm f/4.5L USM lens. Photo by George Lepp.

EF 600mm f/4L USM

Focus drive:	Ultrasonic
Angle of view:	4° 10′
Lens construction:	9 elements in 8 groups
Minimum aperture:	f/32
Minimum focus distance:	19.7 ft. (6.0 m)
Length:	18 in. (456 mm)
Weight:	13.2 lb. (6,000 g)
Lens hood:	ET-161
Filter size:	48mm Drop-in

This remarkable lens offers most of the features of the EF 500mm f/4.5L USM in a 20% longer focal length, with an even faster maximum lens aperture. Today there are others like it, but at the time of its introduction in 1988 the 600mm f/4L USM was (like so many Canon EF lenses) the first of its kind.

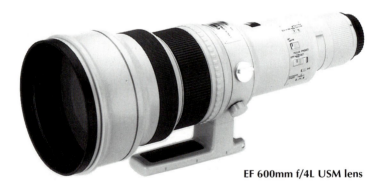

EF 600mm f/4L USM lens

The autofocus system offers focus preset and a user-selectable AF range of 19.7 feet (6 m) to infinity, 49 feet (15 m) to infinity, or 19.7 feet (6 m) to 49 feet (15 m). The manual-focusing system is assisted by the Ultrasonic motor and has three speed settings.

The 600mm f/4L is highly corrected, using one fluorite and two UD elements to remove axial chromatic aberrations. The result is sharp, well-balanced image quality throughout the focusing range.

Price and weight are the only penalties for owning this lens; if you can tolerate them, the photographic possibilities are enormous.

Add the Extender EF 1.4x and you have a mind-boggling 840mm f/5.6 autofocusing telephoto lens, ready to reach out for flying birds, planes, and other fast-moving subjects. The Extender EF 2x turns the lens into a 1200mm focal length that delivers sharp images, but loses the AF capability.

EF 1200mm f/5.6L USM

Focus drive:	Ultrasonic
Angle of view:	2° 5′
Lens construction:	13 elements in 10 groups
Minimum aperture:	f/32
Minimum focus distance:	46.0 ft. (14.0 m)
Length:	33 in. (836 mm)
Weight:	36.3 lb. (16,500 g)
Lens hood:	Built-in
Filter size:	48mm Drop-in

It's hard to know where to start talking about this lens. There are very few of them around, and with a high five-figure sticker price, it's doubtful your local camera shop is going to stock one any time soon. Presently the fastest lens of its length available for AF cameras, the EF 1200mm f/5.6L USM is an updated version of the

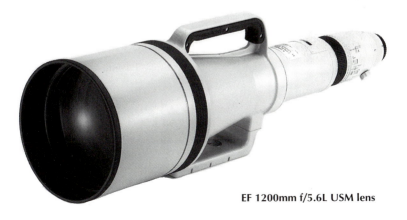

EF 1200mm f/5.6L USM lens

prototype FD 1200mm lens, with the same optical design (minus the 1.4x extender built into the FD version). The newer lens has all the features of the EF super telephoto group, including variable-speed, full-time manual focus, preset-focus capability, and an adjustable autofocus range. The photographer can select a distance band of 46 feet (14 m) to infinity, 98.4 feet (30 m) to infinity, or 46 feet (14 m) to 98.4 feet (30 m). Switching between vertical and horizontal utilizes the same one-touch system as the EF 600mm f/4L USM. With the addition of either the Extender EF 1.4x or Extender EF 2x, the lens will become, respectively a 1680mm f/8 or a 2400mm f/11 optic, which, of course, will no longer autofocus.

Canon currently loans the 1200mm f/5.6L to qualified professionals at special events such as the Super Bowl, World Cup, or the Olympics, but the awesome price tag means that most of us will only get to see this incredible lens from the stands or at photo trade shows. But then again, how often do we really need a lens that weighs 36 pounds and is almost a yard long? If you do require a 1200mm optic, it might make more sense to use the EF 600mm f/4 with the Extender EF 2x. Admittedly you'll be at f/8 instead of f/5.6, and you won't have autofocus. But with the leftover change you could buy a nice summer home, or maybe send your kid to the university for a semester or two!

Zoom Lenses

Canon has made a major commitment to zooms, which have become its largest and fastest-growing group of lenses. In fact, several new zooms were added while this book was in preparation. Some of this activity is undoubtedly due to the popularity of the snapshooter-oriented Rebel cameras, for which the convenience of zoom lenses is a strong selling point. An equally important factor has been technological advances in zoom-lens design and manufacturing. Simply put, zooms are getting much better and, at the same time, less expensive to produce. Although the Rebel market is significant, rest assured that Canon has not forgotten the advanced amateur and professional photographer.

Several objections to zoom lenses have been around for as long as we can remember. The first is that zooms are not as sharp as fixed focal length lenses. This was valid a decade or so ago, when the photographs produced by most zoom lenses did not have the sharpness or contrast of those made with fixed focal length lenses. The discrepancy was due to the high number of lens elements in a zoom, and to the limitations of then-current optical technology.

Current zoom lenses, especially those with aspherical elements and achromatic design, are far superior to their predecessors. But remember, Canon has not turned all its attentions to zoom lenses: fixed focal length lenses are constantly being improved as well. However, the differential has narrowed considerably, and many current zooms actually equal the performance of fixed lenses. For your authors, zoom lenses have become the tools of choice in many instances.

Another venerable complaint is that zooms are slower than fixed focal length lenses. This still tends to be true, but some zooms are now available with relatively fast f/2.8 apertures. Size and weight are also valid concerns with zoom lenses. Although they are becoming smaller, expect to tote some extra weight if you opt for a zoom with a fast aperture.

One way that Canon (and others) has been able to shave ounces and inches off zoom lenses is by designing them with variable maximum apertures. Not long ago, a zoom lens with a variable

This secluded beach on the island of Kaui was photographed to show off the expansive angle of view of a 20-35mm zoom lens. Photo by George Lepp.

f/stop was a real liability, because many photographers used hand-held light meters and automatic flash units with external sensors. This meant that as the lens was zoomed, the exposure had to be recalculated to compensate for the changing f/stop. With current TTL (through-the-lens) light meters and dedicated flash units, such corrections are no longer required in most shooting situations. Unlike some other brands, Canon EOS cameras give an accurate readout of the aperture on the LCD panel.

Zoom ranges have also advanced remarkably. Lenses with zoom ratios of 3:1 (70-210mm, for example), or perhaps 4:1 (such as 50-200mm) were considered "cutting edge" a few years ago. Today, however, Canon supplies zooms with ranges up to 10:1, including one of our favorites, the EF 35-350mm f/3.5-5.6L USM. Both authors concur that if we were restricted to owning only one lens, this would be it!

Contemporary zoom lenses, like their predecessors, contain a lot of glass. And the more elements, the more potential for flare, particularly when the subject is back-lighted, or if an intense light source is included in the picture. Modern zooms use special glass, multi-coating, and internal baffling to improve their flare characteristics greatly. Flare can be further reduced, and sometimes eliminated, by the use of a proper lens shade. To that end, Canon has designed zoom-lens shades to give maximum protection against stray light without causing vignetting. Even so, we must admit that zooms still tend to have more flare than fixed focal length lenses.

Zoom lenses generally don't focus as close as equivalent fixed focal length lenses, although this often can be rectified by the use of an extension tube or plus-diopter lens. Also, some zooms exhibit noticeable barrel or pincushion distortion, making them less desirable for architectural or product photography, where rectilinear rendition is often critical.

How do we decide whether to use a zoom for a particular subject or assignment? Well, if the zoom range includes the required focal length(s), and if the aperture is fast enough for the prevailing lighting conditions, chances are we will opt for the zoom. The convenience of zooming to alter the composition usually outweighs any disadvantages that may be present.

Wide-Angle Zoom Lenses

EF 20-35mm f/2.8L

Focus drive:	Arc Form Drive
Angle of view:	94-63°
Lens construction:	15 elements in 12 groups
Minimum aperture:	f/22
Minimum focus distance:	1.6 ft. (0.5 m)
Length:	3-1/2 in. (89.0 mm)
Weight:	1.2 lb. (540 g)
Lens hood:	EW-75
Filter size:	72mm

This lens covers all the wide-angle focal lengths most of us will ever need. Also, it is reasonably-sized, with a relatively-fast maximum aperture. The barrel does not grow as the lens is focused or zoomed, and the front does not rotate, making it easy to use front-lens accessories. The front element has an aspherical design that virtually eliminates distortion, making this lens appropriate for the most critical subjects. Finally, a floating element improves image quality at close-focusing distances.

Drawbacks? First, the EF 20-35mm f/2.8L is neither small nor light, particularly in comparison with the EF 20mm f/2.8 USM. But that's not really fair, because the zoom replaces not only the 20mm lens in your bag, but the 24mm, 28mm, and 35mm as well. Suddenly the 20-35mm f/2.8L doesn't seem so big, and it weighs over a pound less than the combined weight of those four lenses. On the down side, it costs more than the total sum of

EF 20-35mm f/2.8L lens

the four fixed lenses just mentioned. Of course, the zoom gives you all the intermediate focal lengths as well, so it may indeed be a bargain!

EF 20-35mm f/3.5-4.5 USM

Focus drive:	Ultrasonic motor
Angle of view:	94-63°
Lens construction:	12 elements in 11 groups
Minimum aperture:	f/22-27
Minimum focus distance:	1.1 ft. (0.34 m)
Length:	3-1/4 in. (83 mm)
Weight:	11.9 oz. (340 g)
Lens hood:	EW-83
Filter size:	77mm

This has got to be one of the best deals in the Canon line. The EF 20-35mm f/3.5-4.5 USM costs less than one-third as much as the f/2.8L version, is lighter and more compact, and focuses a full six inches closer! The smaller lens also contains three fewer elements, thereby reducing the chance of lens flare. Admittedly, the 20-35mm f/3.5-4.5 USM varies from about one-half to over a full f/stop slower than the f/2.8L, and exhibits a little more distortion with architectural subjects.

As George rarely does architectural shooting and Joe does quite a bit, we have different lens choices in this area. George uses the EF 20-35mm f/2.8L, while Joe prefers the EF 20-35mm f/3.5-4.5 USM for scenics and general subjects, but switches to the 20mm f/2.8 USM for critical architectural work.

EF 20-35mm f/3.5-4.5 USM lens

EF 28-70mm f/2.8L USM

Focus drive:	Ultrasonic motor
Angle of view:	75-34°
Lens construction:	16 elements in 11 groups
Minimum aperture:	f/22
Minimum focus distance:	1.6 ft. (0.5 m)
Length:	4-5/8 in. (117.6 mm)
Weight:	1.9 lb. (880 g)
Lens hood:	EW-83B
Filter size:	77mm

Earlier, we mentioned that remarkable improvements are being made in zoom-lens design. The proof is the EF 28-70mm f/2.8L USM, introduced in 1993 as a replacement for the EF 28-80mm f/2.8-4L USM. Although the 28-80mm was a good performer, the 28-70mm is far better. Lighter, shorter, and with quicker auto-focusing, the new version sacrifices 10 millimeters of focal length, but gains a constant f/2.8 maximum aperture throughout its zoom range. Performance has been improved in just about every way, including the elimination of the previous lens vignetting problem. The EF 28-70mm f/2.8L USM also sports full-time manual-focus capability and a non-rotating front element facilitating the use of lens accessories, such as polarizers.

Finally, Canon enhanced the performance of the EW-83B lens shade supplied with the lens. This may sound a little silly, until you realize that the lens zooms "backward," so that it is physically shortest at 70mm,

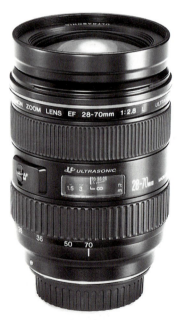

EF 28-70mm f/2.8L USM lens

and longest at the 28mm setting. This allows the use of a deep lens shade (a big advantage when shooting at 70mm), without causing vignetting at 28mm.

With the introduction of the EF 28-70mm f/2.8L USM, it is now possible to zoom your way from 20mm to 200mm with only three lenses, and stay at f/2.8 the whole way!

EF 28-80mm f/3.5-5.6 II USM

Focus drive:	Ultrasonic motor
Angle of view:	75-30°
Lens construction:	9 elements in 9 groups
Minimum aperture:	f/22-38
Minimum focus distance:	1.3 ft. (0.38 m)
Length:	3 in. (77 mm)
Weight:	7.0 oz. (200 g)
Lens hood:	EW-60C
Filter size:	58mm

Early on, Canon offered a 28-80mm zoom that gave good performance, but had a puzzling drawback. When you zoomed, the front element would, at one point, retract into the lens barrel, unless its action was blocked by a filter. You either had to forgo filters, or give up part of the zoom range! In all fairness, the lens was introduced at the same time as the EOS Elan/100, and was probably never meant for the pro or serious amateur.

The Mark II version has ironed out the problem with the "disappearing" filter ring, and we assume that performance

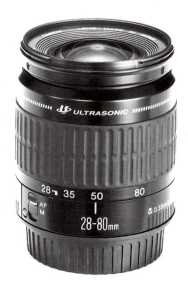

EF 28-80mm f/3.5-5.6 II USM lens

has perked up a bit as well. To be truthful, neither of us has shot with this zoom, because we are, perhaps unfairly, put off by the plastic lens mount common to several popularly-priced lenses.

EF 28-105mm f/3.5-4.5 USM

Focus drive:	Ultrasonic motor
Angle of view:	75-23° 20'
Lens construction:	15 elements in 12 groups
Minimum aperture:	f/22-29
Minimum focus distance:	1.6 ft. (0.5 m)
Length:	2-13/16 in. (72 mm)
Weight:	13.1 oz. (375 g)
Lens hood:	EW-63
Filter size:	58mm

This is a zoom we both use regularly, in place of a standard lens. It is professionally sharp, compact, lightweight, and highly-corrected throughout the generous zoom range. Other fine attributes include a non-rotating front element, and the ability to focus manually without switching out of the autofocus mode. In all, the EF 28-105mm f/3.5-4.5 USM is a great "walk around" lens. Its shortest focal length is sufficiently wide for landscapes and street scenes, and the telephoto end is perfect for portraits or isolating details in a scene (A technique George refers to as "optical extraction.") Add a plus-diopter lens such as the Canon Close-up lens 250D or 500D, and this zoom becomes a better-than-average macro lens as well. If you want to travel light and yet cover a large variety of shooting possibilities, you should definitely consider the EF 28-105mm f/3.5-4.5 USM.

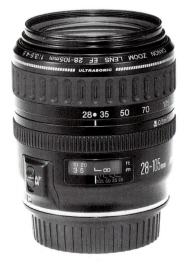

EF 28-105mm f/3.5-4.5 USM lens

The 28mm setting of the EF 28-105mm f/3.5-4.5 USM lens was used for this shot of Pigeon Point lighthouse on a foggy morning. Photo by Joseph Dickerson.

As a shaft of light illuminated the lighthouse, the focal length of the EF 28-105mm f/3.5-4.5 USM lens was zoomed to 105mm. Patience and the ability to quickly change the composition was the key to getting this photograph. Photo by Joseph Dickerson.

Standard Zoom Lenses

EF 35-80mm f/4-5.6 III

Focus drive:	DC motor
Angle of view:	63-30°
Lens construction:	8 elements in 8 groups
Minimum aperture:	f/22-32
Minimum focus distance:	1.3 ft. (0.38 m)
Length:	2-5/8 in. (65 mm)
Weight:	6.1 oz. (175 g)
Lens hood:	EW-54II
Filter size:	52mm

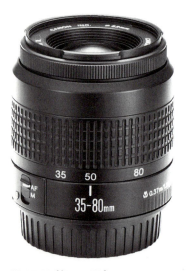 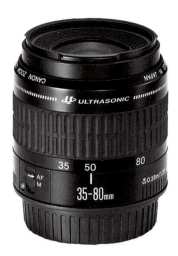

EF 35-80 f/4-5.6 III lens **EF 35-80mm f/4-5.6 USM lens**

Canon must sell a lot of EF 35-80mm zooms, because they sure have made a bunch of them over the years. We presume that the Ultrasonic version will be marketed concurrently with the non-Ultrasonic Mark III, as was the case in previous generations. Confusingly, these lenses all have practically the same specifications.

The number of elements, focusing range, even the weight and dimensions are virtually identical. The Mark III does have a new lens hood, and the lens is a fraction heavier and longer than its predecessors.

EF 35-80mm f/4-5.6 USM

Focus drive:	Ultrasonic motor
Angle of view:	63-30°
Lens construction:	8 elements in 8 groups
Minimum aperture:	f/22-32
Minimum focus distance:	1.3 ft. (0.38 m)
Length:	2-3/8 in. (61 mm)
Weight:	6.0 oz. (170 g)
Lens hood:	EW-54
Filter size:	52mm

These zooms were designed for the Rebel cameras, and they share the aforementioned polycarbonate lens mount. Plastic aside, we believe that some may find the 35-80mm zoom range too limiting. It is, however, an excellent alternative to the standard 50mm lens. So, for folks who want some versatility, but don't see themselves needing either extremely long or short focal lengths, this could be the lens of choice.

EF 35-105mm f/4.5-5.6 USM

Focus drive:	Ultrasonic motor
Angle of view:	63-23° 20'
Lens construction:	13 elements in 12 groups
Minimum aperture:	f/22-27
Minimum focus distance:	2.9 ft. (0.85 m)
Length:	2-1/2 in. (63 mm)
Weight:	9.9 oz. (280 g)
Lens hood:	EW-60B
Filter size:	58mm

This is another focal-length range where Canon has offered a number of choices. The first EF 35-105mm zoom was an autofocus version of the very successful FD 35-105 f/3.5-4.5; the EF lens was in turn superseded by an updated version. Currently, the EF

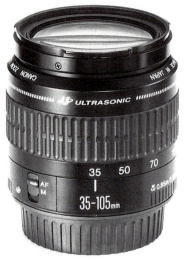

35-105mm f/4.5-5.6 USM, designed for the enthusiast, is the only lens in this range.

Our experience with Canon 35-105mm zooms (and we've used most of them) indicates that the EF 35-105mm f/4.5-5.6 USM could very well be a gem. It sports an aspherical element, and four special lightweight elements to speed up autofocus performance. But frankly, we are spoiled by the slightly longer focal length offered by the EF 28-105mm f/3.5-4.5 USM.

EF 35-105mm f/4.5-5.6 USM lens

EF 35-135mm f/4-5.6 USM

Focus drive:	Ultrasonic motor
Angle of view:	63-18°
Lens construction:	14 elements in 12 groups
Minimum aperture:	f/22-32
Minimum focus distance:	2.5 ft. (0.75 m)
Length:	3-3/8 in. (86 mm)
Weight:	15 oz. (425 g)
Lens hood:	EW-62
Filter size:	58mm

With a zoom range of almost 4:1, this lens offers real reach, plus an honest telephoto effect. It also has Ultrasonic focusing, an aspherical element (glass-molded type) to reduce astigmatism and

spherical aberration, and a close-focus limit of 2.5 feet. This lens is also blessed with internal focusing, so the front element does not rotate. For the photographer who prefers a zoom lens with significant magnification and doesn't need anything wider than 35mm, this is a great choice.

The EF 35-135mm f/4-5.6 USM was the first popularly-priced Canon lens with an Ultrasonic focusing system, and is measures about 8 percent shorter and 10 percent lighter than the EF 35-135mm f/3.5-4.5 that it replaced.

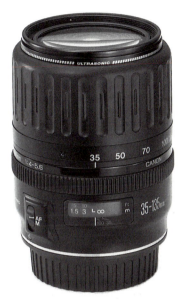

EF 35-135mm f/4-5.6 USM lens

EF 35-350mm f/3.5-5.6L USM

Focus drive:	Ultrasonic motor
Angle of view:	63-3° 30'
Lens construction:	21 elements in 15 groups
Minimum aperture:	f/22-32
Minimum focus distance:	2.0 ft. (0.6 m)
Length:	6-9/16 in. (167 mm)
Weight:	3.0 lb. (1,385 g)
Lens hood:	EW-78
Filter size:	72mm

An editorial problem: Does this lens belong with the wide-angle zooms, because it starts out at 35mm? Or perhaps we should put it in the telephoto zoom section, with the others that reach out to about 300mm? We finally decided to list the remarkable EF 35-350mm f/3.5-5.6L USM as a standard zoom. Whatever category it's in, this is an excellent lens!

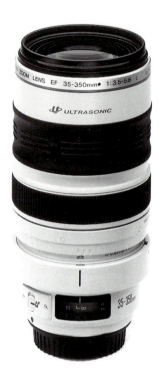

When first confronted with the specs for the 35-350mm lens, many photographers reacted in predictable fashion: "That's interesting, but I'll bet it will be too big and heavy to hand-hold." "It won't focus close enough to be practical." "It won't balance well on the camera." "It will weigh a ton." "Or........," well, you fill in the rest. In actuality, however, the lens performs, focuses, feels, and even looks great.

On-camera balance is quite nice, and although the lens grows considerably in length as it zooms, it is still hand-hold-able. Of course, hand-holding any 350mm lens at slower shutter speeds is asking for unsharp photographs, so be sure to use a tripod whenever possible.

EF 35-350mm f/3.5-5.6L USM lens

Focusing spans the distance from infinity to the close limit of two feet in a blazing 0.37 seconds, without requiring the front element to rotate. And the focus ring travels with the zoom ring, so that their relative distance is unchanged, for easy manual focusing. Of course, manual focus is available at any time without the need to switch out of the autofocus mode.

If you only want to bring one lens, the EF 35-350mm f/3.5-5.6L USM is an excellent choice. It offers an extremely versatile range of focal lengths. The photographer can include the whole band or a single musician without changing positions. Photo by Joseph Dickerson.

A controversy has been raging ever since the first "one-touch" zoom lens was introduced. Proponents of the "two-touch" system, with its separate zoom and focus controls, have argued that lenses using a single zoom/focus ring tend to creep or slip if the lens is pointed up or down. And with a great number of the lenses we've used over the years, this has indeed been a problem. Then again, while two-touch zooms may be stable, you can't focus and zoom them at the same time. With autofocus lenses, much of this controversy becomes moot, but Canon has added a very nice feature that should quiet even the most ardent opponent of one-touch zoom lenses. The EF 35-350mm f/3.5-5.6L is equipped with a unique resistance adjustment, which allows the photographer to increase or decrease the friction of the zoom ring or, if desired, to lock the ring at any setting.

A word about the close-focusing distance of the EF 35-350mm f/3.5-5.6L USM: The minimum focus is listed as two feet, which is true for focal lengths from 35mm out to 135mm, where you get a

subject reproduction of 0.25X. At longer focal lengths the minimum focus increases, reaching 7.2 feet (2.2 meters) at the 350mm setting.

So this zoom is good, but is it really a universal lens as some have claimed? Well, the EF 35-350mm f/3.5-5.6L makes sharp, excellent-contrast images at all focal lengths, but it's neither lightweight nor very compact. Also, the maximum aperture is on the slow side at the longer focal lengths. And the price might scare off the faint-of-heart, and some of the not-so-faint as well. If you can live with these drawbacks, however, the EF 35-350mm f/3.5-5.6L could very well be the only lens you need.

Alternately, you can use the 35-350mm as the linchpin in a minimal lens system. Just add either 20-35mm zoom, and you have a continuous range of 20-350mm, with professionally sharp images, from only two lenses! George has successfully completed numerous assignments with such a pair, plus the EF 600mm f/4.0L USM for maximum telephoto effects.

The incredible 10-to-1 zoom range of the EF 35-350mm f/3.5-5.6L USM lens is apparent in this close-up of an individual piper from the Canadian 48th Highlanders. Photo by Joseph Dickerson.

Telephoto Zoom Lenses

This category has been popular ever since zooms for 35mm SLRs were introduced, and it has benefited greatly from advances in lens design and manufacturing. Early SLR zooms were in the 70mm or 80mm to 200mm or 210mm range, which is still common today. In addition, some zoom ranges now extend out to 300mm. These focal lengths offer a true telephoto effect, and yet are easy to handle, making them very popular as a first telephoto lens acquisition. Although most have relatively slow maximum apertures, commonly from f/3.5 to about f/4.5, a few are as fast as f/2.8. Variable apertures have become the norm, because they allow designers to create more compact and highly-corrected lenses.

EF 70-210mm f/3.5-4.5 USM

Focus drive:	Ultrasonic motor
Angle of view:	34-11° 20'
Lens construction:	14 elements in 10 groups
Minimum aperture:	f/27-32
Minimum focus distance:	3.9 ft. (1.2 m)
Length:	4-3/4 in. (121 mm)
Weight:	1.2 lb. (550 g)
Lens hood:	ET-65II
Filter size:	58mm

Canon has had a long time to perfect this design, as there has been a 70-210mm zoom in the EOS line almost since day one. The current version is a complete redesign of the original EF 70-210mm f/4, which was considerably larger and heavier, and focused much more slowly. In fact, about the only things the two lenses share is their zoom range and their minimum focusing distance. The EF 70-210mm f/3.5-4.5 USM has an oversized zoom ring that makes it very comfortable to hold and easy to operate. A rear-focusing system prevents the lens from "growing" as it focuses, and the Ultrasonic motor allows manual focusing at any time. This lens is a great starter telephoto, and its relatively fast minimum aperture allows hand-held operation in a variety of lighting conditions.

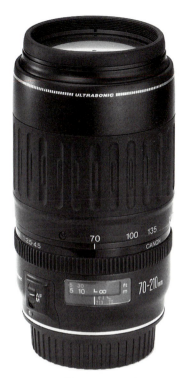

EF 70-210 f/3.5-4.5 USM lens

EF 75-300mm f/4-5.6 II USM

Focus drive:	Ultrasonic motor
Angle of view:	32° 11' - 8° 15'
Lens construction:	13 elements in 9 groups
Minimum aperture:	f/32-45
Minimum focus distance:	4.9 ft. (1.5 m)
Length:	4-13/16 in. (122.1 mm)
Weight:	1.1 lb. (495 g)
Lens hood:	E-58U
Filter size:	58mm

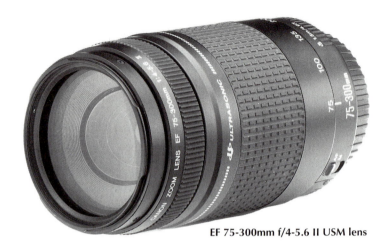

EF 75-300mm f/4-5.6 II USM lens

Another recent upgrade of an established design, the EF 75-300 f/4-5.6 II USM is a 4:1 zoom designed with Rebel cameras in mind. It has a metal lens mount, undoubtedly as a concession to its weight and size. Design changes include the use of lead-free glass to help address environmental concerns. Canon has also enhanced the rubber grip on the zoom collar for a more secure hold.

The EF 75-300 f/4-5.6 II USM is a versatile lens, covering the most popular telephoto focal lengths for sports, action, and portrait photography. This recently introduced zoom is the only current Canon model in the 75-300mm range, although previous versions may still be available at some camera shops.

EF 80-200mm f/2.8L

Focus drive:	Arc Form Drive
Angle of view:	30-12°
Lens construction:	16 elements in 13 groups
Minimum aperture:	f/32
Minimum focus distance:	5.9 ft. (1.8 m)
Length:	7-5/16 in. (186 mm)
Weight:	2.9 lb. (1,330 g)
Lens hood:	ES-79
Filter size:	72mm

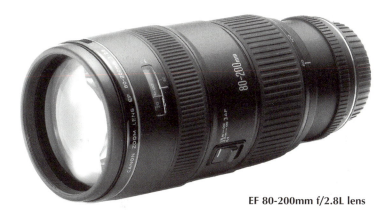

EF 80-200mm f/2.8L lens

EF 70-200mm f/2.8L USM

Focus drive:	Ultrasonic motor
Angle of view:	34-12°
Lens construction:	18 elements in 15 groups
Minimum aperture:	f/32
Closest focus:	4.9 ft. (1.5 m)
Length:	7-5/8 in. (193.6 mm)
Weight:	2.8 lb. (1,275 g)
Lens hood:	ET-83
Filter size:	77mm

We've deviated from our criteria to include a lens that was discontinued recently, the EF 80-200mm f/2.8L, as well as the model that replaced it, the EF 70-200mm f/2.8L USM. First, because the 80-200mm is a very good optic that shouldn't be ignored simply because it's not the latest model. Second, because you may be able to save considerable money by buying the older version. This may happen as previously rare, used examples of the EF 80-200mm f/2.8L become more plentiful, driving down the price on this lens.

If you compare specifications, most of the differences between the lenses are pretty obvious. The 70-200mm has the advantage of Ultrasonic focusing, is slightly lighter, focuses closer, and gives

EF 70-200mm f/2.8L USM lens

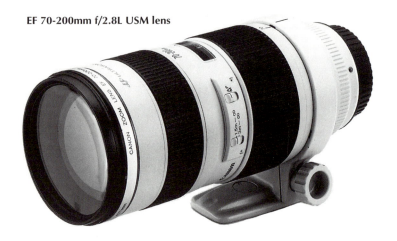

four degrees wider coverage on the low end of the focal length range. In addition, the new lens uses four UD elements instead of three, and offers internal (rather than rear element) focusing with full-time manual focus override. But what's really exciting is that the EF 70-200mm f/2.8L USM is fully compatible with the EF Extenders!

Yes, your little 70-200mm f/2.8 zoom can become a 98-280mm f/4.0 or a 140-400mm f/5.6 that autofocuses! What's more, the close-focus distance is still only 4.9 feet (1.5 m), compared with 8.2 feet (2.5 m) for the EF 300mm f/4L, or 11.5 feet (3.5 m) for the EF 400mm f/5.6L. It's easy to see why nature photographers will especially love this lens. Like its predecessor, the EF 70-200mm f/2.8L USM lets you select two focusing ranges, either 4.9 feet (1.5 m) to infinity, or 9.8 feet (3 m) to infinity, the latter giving a bit faster focusing.

So, should you buy the new lens or wait until the price comes down on the discontinued model? Should you switch lenses if you already own the EF 80-200mm f/2.8L? For us, the deciding factor was the compatibility of the new version with the EF Extenders. Do you know anyone who wants to buy a used 80-200mm zoom?

EF 80-200mm f/4.5-5.6 II

Focus drive:	DC motor
Angle of view:	30-12°
Lens construction:	10 elements in 7 groups
Minimum aperture:	f/22-27
Closest focus:	4.9 ft. (1.5 m)
Length:	3-1/8 in. (78.5 mm)
Weight:	8.8 oz. (250 g)
Lens hood:	E-52
Filter size:	52mm

This extremely compact lens is another recent addition to Canon's line of popularly-priced lenses. Canon is constantly introducing new lenses in this line, some of which seem very similar to their predecessors. Actually, the company keeps finding new ways to bring down the cost of lenses, while improving their optical and mechanical quality. One example is the use of molded rather than ground-and-polished aspherical lens elements. Other improvements stem from new manufac-

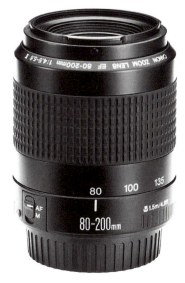

turing techniques which benefit both the amateur and professional markets.

On the spec sheet, the EF 80-200mm f/4.5-5.6 II appears virtually unchanged from the Mark I model. But the current lens has improved focusing speed, accomplished by utilizing a front element rotation focusing system. The rotating front end makes it awkward to use certain filters, but this doesn't present a problem for those not inclined to use polarizers or split neutral density filters.

EF 80-200mm f/4.5-5.6 II lens

EF 100-300mm f/4.5-5.6 USM

Focus drive:	Ultrasonic motor
Angle of view:	24-8° 15′
Lens construction:	13 elements in 10 groups
Minimum aperture:	f/32
Minimum focus distance:	4.9 ft. (1.5 m)
Length:	4-3/4 in. (121 mm)
Weight:	1.2 lb. (540 g)
Lens hood:	ET-65II
Filter size:	58mm

The EF 100-300mm f/4.5-5.6 USM is another lens that is shared by the authors. We have always found this range to be very useful, even in the ancient days when you had to focus for yourself. Now, George uses both current offerings: the Ultrasonic version for its focusing speed, accuracy, and quietness; and the EF 100-300mm f/5.6L for critical image sharpness. The excellent on-camera balance of the Ultra-sonic lens makes it eminently hand-holdable, despite earlier caveats about tripods. And it has a non-rotating front element, for optimum use of filters.

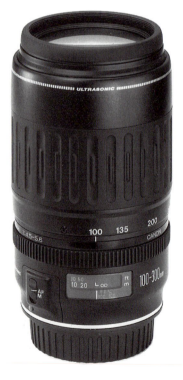

Years ago, Joe speculated that someday his kayak, bicycle, and back-packing trips would be chronicled with two lenses. At the time, he predicted that the lenses would be a 28mm wide angle and a 70-210mm zoom. Well, his prophesy has come to pass, although the actual duo

EF 100-300mm f/4.5-5.6 USM lens

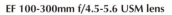

consists of the EF 28-105mm f/3.5-4.5 USM and the EF 100-300mm f/4.5-5.6 USM.

We both enjoy combining the EF 100-300mm f/4.5-5.6 USM with plus-diopter lenses, such as the Canon 250D or 500D Close-up lenses, for macro subjects. In the field, this is even more convenient than using a macro lens, as you can zoom to adjust composition and magnification.

EF 100-300mm f/5.6L

Focus drive:	Arc Form Drive
Angle of view:	24-8° 15′
Lens construction:	15 elements in 10 groups
Minimum aperture:	f/32
Minimum focus distance:	4.6 ft. (1.4 m)
Length:	6-9/16 in. (167 mm)
Weight:	1.5 lb. (695 g)
Lens hood:	ET-62II
Filter size:	58mm

This lens is not as small as the EF 100-300mm f/4.5-5.6 USM, nor does it focus as quickly, but it sure is sharp. The EF 100-300mm f/5.6L was one of the first EOS L lenses, and it still has a niche in the market. The real advantage of the L is its wide-open performance, which is noticeably superior to the Ultrasonic version at f/5.6 (although by f/11 the advantage is much harder to spot). A

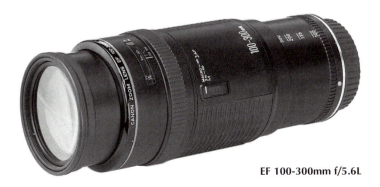

EF 100-300mm f/5.6L

high degree of correction is achieved through the use of both fluorite and UD elements, which preserve image quality throughout the zoom range.

The L lens also focuses a bit closer than the Ultrasonic version (4.6 feet/1.4 m as opposed to 4.9 feet/1.5 m), and it maintains the minimum focus distance at all focal lengths. A final plus: at the present time, the EF 100-300mm f/5.6L is the least expensive lens in the L series.

The EF 100-300mm f/4.5-5.6 USM lens is ideal for fast-paced action like Women's Pro Beach Volleyball. With the lens set at 100mm, the photographer was able to include the "setter" and the "spiker" in the picture. Photo by Joseph Dickerson.

For this shot, the EF 100-300mm f/4.5-5.6 USM was zoomed out to 250mm to isolate the action. Photo by Joseph Dickerson. ⇨

119

Page 121, above:
Because he was photographed with a EF 500mm f/4.5L USM lens, the Frisbee competitor fills the frame allowing us to see the intense concentration on his face. The lens' shallow depth of field reduced a distracting background to a soft blur. Photo by Joseph Dickerson.

Page 121, below:
Zoom lenses, such as the EF 35-350mm f/3.5-5.6L USM, are great for action sports photography. The photographer can follow a moving subject easily and compose each photograph quickly by zooming the lens. Here a windsurfer gets "air" off the coast of San Simeon, California. Photo by George Lepp.

Page 122, above:
The EF 28-105 f/3.5-4.5 USM combines several commonly needed focal lengths in a very compact package. The lens' non-rotating front element facilitated the use of a circular polarizer for this photo of lenticular clouds over Mono Lake, California at sunset. Photo by George Lepp.

Page 122, below:
The sweep of a desert sand dune is isolated with an EF 500mm f/4.5L USM lens. Those aren't insects on the lower dunes, they're ATVs included for scale. Photo by George Lepp.

Page 123:
Here the TS-E 24mm f/3.5L allows the photographer to put the Scheimpflug rule to work by tilting the lens plane to match the plane of the subject. The resulting photograph has depth of field that includes the bearberry inches from the camera and Mount McKinley 30 miles away. Photo by George Lepp.

Page 124:
The EF 100-300mm f/4.5-5.6 USM lens used for "optical extraction" isolates the larkspur while recording the foreground and background fireweed as delicate veils of color. Shot in Denali National Park. Photo by George Lepp.

Page 125:
The EF 15mm f/2.8 Fish-eye lens was placed under these blue flag irises growing near Mono Lake, California. The lens was set at a close focus distance and stopped down for depth of field. Note the lens' characteristic distortion of the horizon and the flower stems. Photo by George Lepp.

Page 126:
The EF 20-35mm f/2.8L lens was set at 20mm and stopped down to focus on the field of poppies at the California Poppy Preserve in Lancaster, California. This very versatile lens has become a favorite of many nature photographers and photojournalists. Photo by George Lepp.

Page 127:
The versatile zoom range of the EF 28-105mm f/3.5-4.5 USM lens can capture sweeping landscapes at a wide-angle setting as in this shot of the Alaska Range in Denali National Park. At longer focal lengths it is ideal for portraits or close-ups. Photo by George Lepp.

Page 128:
The TS-E 45mm f/2.8 lens records the Los Angeles skyline at sunset. The lens was tilted upwards to prevent the convergence of the buildings' vertical lines—the most common application of these lenses. Photo by Joseph Dickerson.

Macro Lenses

The lenses we will be discussing in this section are true macros, not merely zooms with a macro close-up setting. Real macro lenses are characterized by very close focusing, resulting in maximum on-film image rendition from one-half to full life-size. Although some of these lenses focus to infinity, they are generally optimized to give the sharpest results in the close-up range. Flat-field optical design allows them to image a flat subject on the flat film plane with better edge-to-edge sharpness than standard lenses. This makes them the best choice for copy work, provided the subject is two dimensional.

When discussing how close macro lenses will allow you to focus, many photographers (and technical books) use reproduction ratios, such as 1:1 or 4:1, etc. In use, however, these can be rather bewildering, as similar ratios, such as 1:2 and 2:1, could easily be misconstrued. We prefer using the actual image magnification, such as 0.5X, 4X etc., as we find it much easier to comprehend. So 1X means the subject will be recorded on film at the actual size (a 1:1 or life-size rendition), 2X means it is twice the

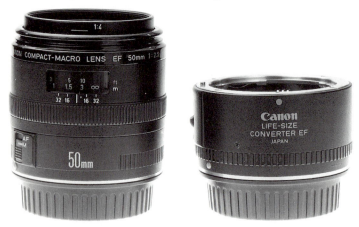

EF 50mm f/2.5 Compact Macro lens and Life-Size Converter EF. Photo by Joseph Dickerson.

actual size on film (a 2:1 ratio), and 0.5X means it is one-half life-size on film (a 1:2 ratio).

Canon currently offers two autofocusing macro lenses, the EF 50mm f/2.5 Compact Macro and the EF 100mm f/2.8 Macro. In addition they have a Life Size Converter EF for use with the EF 50mm f/2.5 Compact Macro, and two lenses designed for the Auto Bellows FD. Although the latter pair, the Macrophoto 35mm f/2.8 and Macrophoto 20mm f/3.5, are not strictly EOS lenses, they are extremely useful for photographers desiring to focus in the 2X to 10X macro range.

EF 50mm f/2.5 Compact Macro

Focus drive:	Arc Form Drive
Angle of view:	46°
Lens construction:	9 elements in 8 groups
Minimum aperture:	f/32
Minimum focus distance:	0.75 ft. (0.23 m)
Length:	2-1/2 in. (63 mm)
Weight:	9.9 oz. (280 g)
Lens hood:	None
Filter size:	52mm

Life Size Converter EF

Magnification:	1.4x (usable in the 0.25X to 1X reproduction range only)
Lens construction:	4 elements in 3 groups
Length:	1-3/8 in. (34.9 mm)
Weight:	5.6 oz. (160 g)

The EF 50mm f/2.5 Compact Macro lens focuses from infinity to 9 inches (giving a magnification of 0.5X) without accessories. It is extremely sharp throughout the focusing range, thanks to a float-ing-element design that optimizes the image for the particular dis-tance set. The Arc Form Drive provides rapid autofocusing throughout this extended range, while the relatively fast f/2.5 max-imum aperture offers considerable versatility.

Add the Life Size Converter EF to the Compact Macro, and you can focus in the 0.25X to 1X range. The converter is no mere extension tube, but a complete optical system that increases the focal length of the lens to 70mm, and optimizes performance in the close-focusing range.

Traditionally, macro lenses are optimized for the best performance at a very close subject-to-lens distance (usually around 0.5X or 1X rendition), with some compromises at longer distances. What Canon has done is to make a lens that is extremely sharp at all distances, and then provide the Life Size Converter EF to improve performance (as well as autofocus speed) in the 0.25X to 1X range. There is some overlap in the close-focusing range with and without the converter, but infinity focus is not possible with the converter in place.

EF 100mm f/2.8 Macro

Focus drive:	Micromotor
Angle of view:	24°
Lens construction:	10 elements in 9 groups
Minimum aperture:	f/32
Minimum focus distance:	1.0 ft. (0.3 m)
Length:	4-1/8 in. (105.5 mm)
Weight:	1.4 lb. (650 g)
Lens hood:	None
Filter size:	52mm

The EF 100mm f/2.8 macro lens is even more versatile than its 50mm cousin, focusing all the way from infinity to 1X (life-size) without accessories. Relatively high speed and a 100mm focal length make the lens useful for shooting sports, studio product shots, and, of course, portraiture, as well as macrophotography.

The optical design of this lens is rather unusual, as it is divided into two sections. The front portion is a Gauss-type group that greatly reduces focusing-distance-related aberrations, while the fixed rear group functions as an extender. This improves optical and autofocus performance, yet minimizes the amount of lens extension required, reducing overall lens size. The focusing system

is also unusual in that it uses a traditional electric motor with a long drive shaft rather than an AFD or USM type.

For field photography of wildflowers or insects, the EF 100mm f/2.8 Macro has several advantages over the EF 50mm f/2.5 Compact Macro. The longer focal length means that a given magnification is achieved at twice the camera-to-subject distance. This added working room makes it much easier to place a flash unit, reflector, or other lighting device where needed to achieve the desired effect. It's also less likely that a gorgeous butterfly will interpret the front of your lens as a hungry predator looking for lunch, and skip out on you.

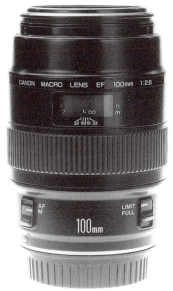

**EF 100mm f/2.8 Macro lens
Photo by Joesph Dickerson.**

Lens choice is a personal matter, but each EF Macro has its own advantages. The EF 50mm f/2.5 Compact Macro is probably best for close-ups of stamps, coins, or other small subjects, and it's a great choice for copying prints or slides. On the other hand, the EF 100mm f/2.8 Macro is at its best in the field doing nature photography. If you're still having a hard time deciding, think about the ancillary applications of each. Is it more important for you to have a lens that will double as a standard focal length, or would you rather have a portrait lens? Naturally, Canon suggests that you buy both.

20mm f/3.5 and 35mm f/2.8 Macrophoto

20mm f/3.5 Macrophoto

Magnification:	4X to 10X with Autobellows FD
Lens construction:	4 elements in 3 groups
Length:	0.78 in. (20 mm)
Weight:	1.23 oz. (35 g)

35mm f/2.8 Macrophoto

Magnification:	2X to 5X with Autobellows FD
Lens construction:	6 elements in 4 groups
Length:	0.88 in. (22.5 mm)
Weight:	2.1 oz. (60 g)

20mm f/3.5 and 35mm f/2.8 Macrophoto lenses with auto bellows FD

These very specialized lenses are designed to fill in the gap between macro lenses (which focus to about 1X) and microscopes (with magnification ratios starting about 20X). Although not technically EOS lens accessories, they will function with EOS cameras, and allow closer focusing than either the EF 50mm f/2.5 Compact Macro or the EF 100mm f/2.8 Macro.

Both Macrophoto lenses are of the short-mount or bellows-mount type, so they have no focusing mechanism of their own, and must be used on the FD Auto Bellows or a similar focusing device. The lens diaphragms are strictly manual, which can be extremely inconvenient with some camera systems. However, Canon EOS cameras have a stopped-down metering mode that

This computer chip was photographed with the 35mm f/2.8 Macrophoto lens on the Auto Bellows at approximately a 2X magnification. Photo by Joseph Dickerson.

allows the light meter to make exposure determinations with the lens closed down to the taking aperture.

To use an EOS camera on the Auto Bellows FD, the FD-EOS Macro Lens Mount Converter is fitted to the rear of the Auto Bellows FD, then the camera body is attached as usual. The 20mm f/3.5 Macrophoto lens allows focusing from a magnification of approximately 4X to 10X, while the 35mm f/2.8 Macrophoto lens will cover the range from around 2X to 5X. That's a total range from twice to ten-times life size! Not only will these lenses permit very close focusing, but they are well-corrected to prevent the image-degrading aberrations normally encountered at such high magnifications. Also, the angled design of the lens front facilitates positioning of light sources without worrying about shadows being cast by the lens itself.

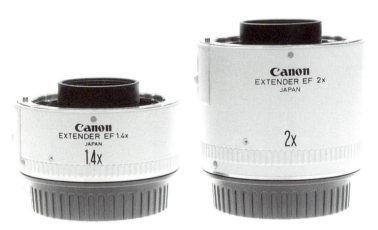

The Canon Extender EF 1.4x and Extender EF 2x
Photo by Joseph Dickerson.

EF Extenders

The concept of tele-extenders (also called tele-converters) has been around for a long time. In fact, an extender is similar in function to the Barlow lens used to increase magnification at the eyepiece of an astronomical telescope. Placing a tele-extender behind a prime lens increases the effective focal length by the magnification factor of the extender. Therefore, a 300mm lens with a 1.4x extender becomes a 420mm lens, and the same lens with a 2x extender becomes a 600mm lens.

Extender EF 1.4x

Magnification:	1.4x
Construction:	6 elements in 4 groups
Length:	1-1/16 in. (27.3 mm)
Weight:	7.1 oz. (200 g)

Extender EF 2x

Magnification:	2x
Construction:	7 elements in 5 groups
Length:	2 in. (50.5 mm)
Weight:	8.5 oz. (240 g)

Because the focal length is being increased without a corresponding enlargement of the lens aperture, the effective f/stop is decreased. This loss of speed is one f/stop for a 1.4x extender, and two f/stops for a 2x extender. For example, the maximum aperture of the EF 300mm f/4L becomes f/5.6 when used with the Extender EF 1.4x, and f/8 when the Extender EF 2x is attached. Although some aftermarket manufacturers offer 3x tele-extenders, the reduction in optical quality and three-stop loss of light makes them highly problematic.

Tele-extenders used to have the reputation of being strictly for amateurs who couldn't justify spending the money for a "real"

telephoto lens. But with today's high-quality telephoto lenses and tele-extenders, the resulting sharpness and contrast meet the standards of professionals as well.

Another big benefit of using tele-extenders is that the focal length is increased without changing the minimum focusing distance. For example, add the Extender EF 2x to the EF 300mm f/2.8L, and it becomes a 600mm f/5.6 lens with a minimum focusing distance of 9.8 feet (3.0 m). That's impressive when you consider that the EF 600mm f/4L lens focuses no closer than 19.7 feet (6.0 m). In addition, the 300mm/2X combination weighs about half as much as the 600mm f/4 lens, and measures nearly 6 inches (152 mm) shorter. Of course the EF 600mm f/4L is a full stop faster, but you can see why so many professionals now take advantage of tele-extenders.

You may wonder which lenses can be used with the Canon EF Extenders, and whether or not they will autofocus. The official word is that the Extender EF 1.4x and EF 2x are to be employed exclusively on the following lenses: EF 200mm f/1.8L, 200mm f/2.8L, 300mm f/2.8L, 300mm f/4L, 400mm f/2.8L, 400mm f/5.6L, 500mm f/4.5L, 600mm f/4L, 1200mm f/5.6L, and the recently

Piedras Blancas light house on the California coast taken with the EF 300mm f/4L. Photo by Joseph Dickerson.

An Extender EF 1.4x was added to the EF 300mm f/4L. The EOS cameras display the effective aperture when used with the EF Extenders. Photo by Joseph Dickerson.

An Extender EF 2x was added to the EF 300mm f/4L for an effective focal length of 600mm. The camera was steadied on a tripod and the lens was stopped down to f/16 to ensure maximum sharpness. Photo by Joseph Dickerson.

introduced EF 70-200mm f/2.8L zoom lens. Our experience, however, has been that extenders work well with other lenses as long as they fit properly.

Each extender has a front element that protrudes into the prime lens, so many Canon lenses cannot physically accommodate them. To get around this limitation, George often adds an extension tube between the EF Extender and the lens. This technique works with many EOS lenses, but because of the added extension the lens will no longer focus to infinity, so you're limited to macro subjects.

Although the EF Extenders are optimized for lenses of 200mm or longer, George has used them with excellent results on many shorter Canon lenses. In fact, one of his favorite setups is the TS-E 90mm f/2.8 tilt/shift lens and the Extender EF 2x, combined to produce a 180mm lens that gives incredible depth of field when the tilt is applied. Another useful combination is the Extender EF 2x and the EF 100mm f/2.8 Macro lens, with an intermediary EF 25mm extension tube. This allows on-film subject magnification of over 2X.

We should also clarify the issue of AF performance with the EF Extenders. When an extender is used, the prime lens will autofocus if the maximum *effective* lens aperture is f/5.6 or faster; if not, the camera will default to manual focus. This is not a result of the amount of light (exposure) entering the lens, but of the actual diameter of the beam of light being focused by the lens. Only if the light fully illuminates the autofocus sensor can it focus accurately.

On the Canon Extender EF 1.4x and EF 2x there are additional contacts to relay aperture information, so the camera will display the effective f/stop and utilize the effective maximum aperture and the combined focal length (necessary in some program modes to key the proper shutter speed). On aftermarket tele-extenders these contacts may be missing, so the camera will display the aperture set on the lens rather than the effective aperture, and the lens may autofocus even if the effective maximum aperture is slower than f/5.6. In this case, there is a good chance the autofocusing will be inaccurate. So if you want to use aftermarket tele-extenders on Canon EF lenses, be sure to check them out carefully before you buy.

Tilt-Shift Lenses

Another area in which Canon has the competitive edge is its design and selection of tilt-shift lenses, which offer perspective control in an unusually flexible and convenient form. Large-format photographers call moving the lens around a vertical axis a "swing," and moving the lens around a horizontal axis a "tilt". The Canon TS-E lenses conveniently allow you to choose either a swing or a tilt depending on the circumstances. Rather than only one or two wide-angle versions, Canon offers three very sensible choices: the TS-E 24mm f/3.5L, the TS-E 45mm f/2.8, and the TS-E 90mm f/2.8. Until the introduction in 1991 of the TS-E trio, all perspective-control lenses were wide-angle designs. Having, at long last, a choice of focal lengths was an important advantage for many photographers.

Almost as welcome was the fully automatic diaphragm of each lens. We realize this may sound a little strange to those who have not previously worked with perspective-control lenses. After all, automatic diaphragms have been used on 35mm SLRs for decades. However, mechanically-activated automatic diaphragms couldn't be made to work on perspective-control lenses due to the contortions they endure. Now, the electronically-controlled lens diaphragm of the EOS makes exposure determination with tilt-shift lenses as easy as with any other lens. Plus, all the automatic exposure (AE) operating modes continue to function normally. The only caveat is that shifting or tilting the lens may cause the meter to read incorrectly, so light readings should be made before any tilt or shift is applied.

Why consider tilt-shift lenses in the first place? After all, for the price of a TS-E you can easily buy a 4x5 view camera and lens. But it's difficult to shoot 35mm film in a 4x5 camera. And shooting 4x5 color and then duplicating it down to 35mm slides for projection just doesn't make much sense. Further, in many situations (such as aviation or marine photography), interiors may be too cramped to accommodate a large camera. So 35mm format becomes your most practical alternative.

As the name implies, perspective-control helps you control

image rendition. For example, with architectural subjects it often becomes necessary to aim the camera up to include the top of the subject. When you do this, the sides of the building appear to converge. (The effect is similar to the vanishing-point perspective observed when shooting down railroad tracks.) If you keep the film plane (back of the camera) parallel to the building, there will be no convergence and the building will retain its normal perspective.

Perspective-control lenses (and view cameras) allow the optical system to slide or shift to include all of the subject without inclining the film plane. With the Canon TS-E lenses, the photographer can easily switch this movement or shift from vertical to horizontal depending on the subject's orientation.

To include the entire building, the camera had to be tipped up. The sides of the building seem to converge, making it appear that the building is leaning back. Photo by Joseph Dickerson.

The operation of the unique tilt feature is a little harder to explain. As you know, you can increase depth of field by stopping down a lens. For example, f/16 gives more depth of field than f/8 if everything else is equal. However, in some circumstances (shooting wildflowers on a windy day, for example), small apertures are not practical because of the correspondingly slow shutter speeds required, which could result in the subject being blurred. The solution is to somehow align the plane of the film, the plane of the subject, and the plane of focus (which is perpendicular to the lens axis), so that all three intersect at an imaginary point. Then you have maximized the depth of field for that situation so just a moderate aperture setting will bring nearly everything into sharp focus. This principle is called the Scheimpflug Rule, and photographers

The distortion has been corrected by holding the camera parallel to the building and using the vertical shift of the TS-E 24mm f/3.5L to include the entire building in the photograph. Photo by Joseph Dickerson.

who work with view cameras use it on a daily basis. Fortunately, it is easier to use Scheimpflug than to say it, because its effect is apparent in the viewfinder.

Even though a small aperture was used for this product shot of a model train, there wasn't enough depth of field to ensure the entire train was in sharp focus. Photo by Joseph Dickerson.

The tilt feature of the TS-E 45mm f/2.8 lens was applied to increase the depth of field to encompass the entire subject. Photo by Joseph Dickerson.

Want some more magic? Imagine that you have an assignment to photograph a painting hanging in a museum. The conditions are that you can't move the painting (it's priceless), you have to use existing light (they don't want hot lights or flash units anywhere near it), and of course it's framed behind glass. Shoot straight on to keep the painting rectilinear and what do you see reflected in the glass? Yes, you and the camera. Move far enough to the side to get your reflection out of the glass and the painting appears trapezoidal rather than rectangular. With a tilt-shift lens, however, you can move the camera gradually until your reflection just disappears, then use a lateral shift to center the painting in the viewfinder.

Have you ever tried to take a two-picture panorama? It's almost impossible to keep everything aligned while you move the camera and tripod from side to side to match up the edge of the frame for the second shot. With a Canon tilt-shift lens, simply shoot the first image with the lens shifted all the way to the left (or right), then shift the lens fully in the other direction and make your second exposure. The two contiguous negatives match perfectly and are easily printed into one panoramic shot.

TS-E 24mm f/3.5L

Focus drive:	Manual
Angle of view:	84°
Construction:	11 elements in 9 groups
Minimum aperture:	f/22
Minimum focus distance:	1.0 ft. (0.3 m)
Length:	3-7/16 in. (87 mm)
Weight:	1.2 lb. (570 g)
Lens hood:	EW-75B
Filter size:	72mm

The widest of the Canon tilt-shift lenses, the TS-E 24mm f/2.8L is a great tool for architectural photography, as well as for scenics. Its 84-degree angle of view will encompass all but the tightest of interiors, or allow you to shoot exteriors in crowded urban areas. The ability of this lens to maximize depth of field also makes it a fine choice for subjects that require a strong near-far composition. Fields of wildflowers, desert sand dunes, or mountain ridges stacked row upon row are just some of the subjects for which this lens is particularly appropriate.

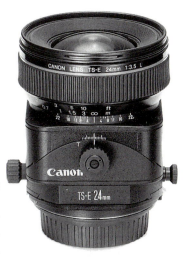

TS-E 24mm f/3.5L Tilt-Shift lens

The TS-E 24mm f/3.5L benefits from an aspherical front element that corrects aberrations that occur when tilting or shifting

and also creates the large circle of illumination required for these movements. A floating-element design is employed to give sharp images with good contrast throughout the focusing range.

TS-E 24mm f/3.5L with the tilt at the zero setting.

TS-E 24mm f/3.5L showing the maximum tilt of 8°.

TS-E 24mm f/3.5L with the shift at the zero setting.

TS-E 24mm f/3.5L showing the maximum 11 millimeter shift. Photos by Joseph Dickerson.

TS-E 45mm f/2.8

Focus drive:	Manual
Angle of view:	51°
Construction:	10 elements in 9 groups
Minimum aperture:	f/22
Minimum focus distance:	1.4 ft. (0.4 m)
Length:	3-9/16 in. (90 mm)
Weight:	1.4 lb. (645 g)
Lens hood:	EW-79B
Filter size:	72mm

The TS-E 45mm f/2.8 has a focal length almost exactly the same as the 43mm diagonal measurement of the 35mm negative. This gives it a "normal" angle of view (similar to that of the concentrated area of human vision), resulting in a lens that is great for scenic photography as well as for product shots. A rear-focusing optical system with a floating design means that the lens doesn't "grow" as you focus, and offers the added advantage of a non-rotating front element.

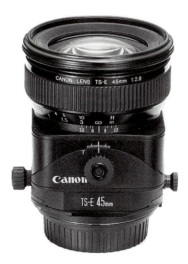

TS-E 45mm f/2.8 Tilt-Shift lens

The TS-E 45mm f/2.8 Tilt-Shift lens is just as useful in the field for archi-
tecture and scenics as it is in the studio for photographing products.
Photo by Joseph Dickerson.

TS-E 90mm f/2.8

Focus drive:	Manual
Angle of view:	27°
Construction:	6 elements in 5 groups
Minimum aperture:	f/32
Minimum focus distance:	1.6 ft. (0.5 m)
Length:	3-7/16 in. (87 mm)
Weight:	1.2 lb. (570 g)
Lens hood:	ES-65II
Filter size:	58mm

This is the world's first telephoto tilt-shift lens, and it has already made believers of many top photographers. Its uses include everything from portraits to tabletop photography, and architecture to macro subjects. Nature photographers can tilt the lens toward the subject's plane to maximize depth of field with minimal stopping down. Conversely, portrait photographers can apply the tilt in the opposite direction to radically limit depth of field, a technique that restricts sharpness to a much shallower range than merely using the lens wide open.

Other Canon accessories further enhance the usefulness of the TS-E 90mm f/2.8. Attaching one of the EF Extenders creates a 126mm or 180mm telephoto lens with tilt/shift capabilities. In fact, George often uses the 180mm configuration to photograph fields of wildflowers. If you have ever tried to photograph flowers using a focal length in the 200mm range, you are aware of the limited zone of sharp focus that is obtainable. With the TS-E 90mm f/2.8 and the Extender EF 2x you can use the tilt feature to create nearly universal focus while shooting from distances that create the

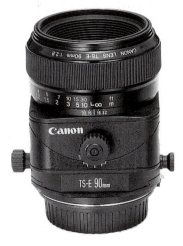

TS-E 90mm f/2.8 Tilt-Shift lens

149

compressed perspective of a telephoto lens. Incidentally, to achieve this same effect with a 4x5 view camera would require a focal length of 540mm!

The addition of an EF 25mm extension tube between the TS-E 90mm f/2.8 and the camera body gives a subject magnification of 0.6X (more than half life-size). You can also add the Extender EF 2x and go beyond life size to 1.3X. Such close-focus capabilities are truly remarkable in a lens that allows tilting to maximize depth of field. And if that's still not close enough, try adding a Canon 500D close-up lens to the above combination for even greater magnification.

The TS-E 90mm f/2.8 Tilt-Shift lens offers unique possibilities for macro photography. For this shot of a Parthenos Sylvia butterfly, the TS-E 90mm f/2.8 was combined with the Extender EF 2x to give an effective focal length of 180mm. The combination provided a minimum focus distance of 1.6 feet and the plane of sharp focus was positioned using the lens' tilt feature. Photo by George Lepp.

Canon EF Lens Accessories

Circular Polarizing Filters PL-C

Canon makes the Circular Polarizing filters PL-C in 52mm, 58mm, 72mm, and 77mm screw-on sizes to fit Canon EF lenses with front-accessory threads, as well as a drop-in version for telephoto lenses with a 48mm filter holder. The drop-in model has an external wheel that lets you rotate the filter to change the effect without removing it from the lens.

Polarizing filters are among the most misunderstood tools in the photographer's kit, so a quick review is in order. These versatile items accomplish what no other filter can, whether you are shooting in color or black and white. By controlling unwanted reflections, they allow you to cut through the glare on a store window, or photograph that record Golden Trout just below the surface of a high mountain lake. You can also remove the reflected blue of the sky from the vivid crimson and gold of the Alaskan fall tundra, for more saturated color reproduction. How do these filters do so much?

Simply put, as light bounces off a reflective surface (such as glass, water, or even foliage) it becomes polarized, which means that it oscillates or vibrates in only one direction rather than many as is the case with unpolarized light. (Reflections off polished metal surfaces have different characteristics and are not controlled well by polarizers.)

A polarizing filter acts like a Venetian blind, only allowing light oscillating in one direction to pass through. When properly aligned (rotated), this effectively reduces or removes the unwanted surface glare. The degree of change depends on the surface itself, the direction of the light, and the relative angle of the camera to the reflective surface. Maximum polarization is usually achieved when the camera-to-subject angle is between 30 and 40 degrees, with the lens axis at right angles to the light source. The effect is clearly visible in the SLR viewfinder, so you merely rotate the filter until you get the desired results.

Many photographers are confused as to which polarizer type,

circular or linear, they should use with their cameras. Although the two types create similar results, they achieve their effects in slightly different ways.

All Canon EOS cameras, plus some of the manual-focus Canon models (including the T-90, T-80, both F-1s, AL-1, FTb, TLb, and FT-QL) require the use of a circular polarizer. These cameras utilize a beam splitter or semi-silvered mirror to channel light to the exposure metering cell(s). Rotating a linear polarizer to certain positions can block a disproportionate amount of light from reaching the meter, resulting in exposure errors. Circular polarizers, however, do not create this problem. Non-AF cameras without a beam-splitter or semi-silvered mirror can use either a circular polarizer or the less-expensive linear type with equal results.

While we are on the subject of filters, it is often claimed that TTL (through-the-lens) metering systems automatically compensate for the light absorption of various filters, so that the photographer need not be concerned with filter-factor adjustments. In many cases, however, this simply is not so, because the metering cells in SLR cameras are not necessarily sensitive to the same wavelengths of light as is the film. Normally this discrepancy is not a problem, but when strongly colored filters (such as black-and-white contrast filters) are placed over the lens, the meter may see a disproportionate decrease in the amount of light passed by the filter. This may manifest itself as over- or underexposure, depending on the circumstances. To prevent this error, you may need to make meter readings without the filter, then place the filter over the lens and manually set the exposure to compensate for the filter factor.

Here's a simple test to determine whether manual adjustment is necessary with your camera: With no filter in place, take a meter reading off an evenly lighted subject. (A KODAK Gray Card is ideal.) Then position the filter over the lens and see if the exposure is reduced by the amount indicated by the filter factor. If the reading is changed by the correct amount (for example, three stops with the 25A dark red filter), you can trust your meter with that filter in place. If the meter indicates more or less exposure compensation than it should, you will have to adjust the exposure or change the exposure index of your film each time you use that filter.

Exposure determination is much easier with polarizing filters. Most of the light loss is due to the neutral density of the filter, so you can simply rotate the polarizer to achieve the desired effect,

and measure the scene normally with the camera's TTL meter. No further adjustment should be required.

Softmat Filters

Portrait photographers often soften their images to reduce the need for retouching, to smooth skin tones, to hide wrinkles and blemishes, and to give an overall radiance to the print. These effects can be achieved with special lenses (such as the Canon EF 135mm f/2.8 with Soft Focus) that utilize a controlled amount of spherical aberration, or with filters that fit in front of or behind a conventional lens.

The Canon Softmat filters combine a sharply-focused image with a slightly blurred one, delicately spreading the highlights into the shadows to create a beautiful photograph that seems to glow from within. The highlights are surrounded by a slight halo, the shadows are luminous, and the mid-tones (such as skin tones) are silky smooth. Note that a Softmat filter, like any soft-focus device, tends to reduce contrast. For best results avoid using a Softmat with very soft lighting, or the image may be too flat and dull.

Don't overlook the use of Softmat filters with subjects other than portraits. Scenics, flowers (both wild and "tame"), still lifes and numerous other subjects lend themselves to the gentle, "nostalgic" interpretation these filters can create.

The Softmat 1 gives a slight softening of the image, while the results created with a Softmat 2 are more dramatic. The effect of either will vary with the focal length and aperture setting of the prime lens, but neither requires any exposure compensation. Both are available in 52mm and 58mm screw-on sizes.

Speaking of soft focus, George has developed a technique for stationary subjects that creates the same "painterly" look usually achieved with soft-focus lenses. He first shoots the subject in sharp focus, then defocuses the image and makes a second exposure on the same frame of film. Because two "layered" images are being created on one frame, each exposure needs to be reduced by half. That is, you close down by one f/stop, or use one shutter speed higher than indicated by the meter for each exposure. This technique very closely duplicates the effect of spherical-aberration portrait lenses, but is impractical for subjects that may move between exposures.

To compare the effects produced by the Canon Softmat filters, the model was first photographed with no filtration applied. Although a person was the subject for this series of shots, don't limit the use of soft-focus filters to portraiture. Photo by Joseph Dickerson.

Choose the Canon Softmat #1 filter to give a subtle overall softness to photographs. Photo by Joseph Dickerson.

A higher degree of diffusion is provided by the Canon Softmat #2 filter.
Photo by Joseph Dickerson.

Close-up Lenses

Close-up lenses (also known as plus-diopter lenses and often incorrectly called close-up filters) are supplementary lenses that screw onto the front of a prime lens to alter its close-focusing characteristics. Although the commonly seen single-element type can produce relatively good images, they lack the edge sharpness and flatness of field that professionals demand in close-up work. Such lenses are therefore relegated to photographers doing less critical work.

Canon now offers three series of high-quality close-up lenses in several sizes, a range that was not previously available from any manufacturer. The first series is the 250D, a two-element achromatic design supplied in 52mm and 58mm screw-on sizes. Canon recommends that these professional-quality lenses be used with focal lengths between 38mm and 135mm. The second series is the 500 single-element type, available in 52mm, 58mm, 72mm, and 77mm sizes, and recommended for lenses with focal lengths from 70mm to 300mm.

The third series is the 500D, a two-element achromatic design similar to the 250D, but with less power. The sizes and focal length recommendations are the same as the budget-priced 500 series.

An important advantage of using close-up lenses for macro work is that no light is lost. With extension tubes, or a close-up bellows, as the focus gets closer the effective f/stop is reduced. This unavoidable loss is due to the inverse-square law. For example, at a reproduction ratio of one-half life-size (0.5X), light transmission is reduced by half (one full f/stop). As you focus closer, the loss gets worse.

But with close-up lenses, the focal length of the lens is altered without extending the distance from the rear element to the film so there is no loss of light. Other major advantages of close-up lenses are that they are far less expensive than a professional-quality macro lens, much smaller, and available to supplement most lenses you already own.

The Canon 250D close-up lens has a focal length of 250mm, so with your prime lens focus set to infinity, the point of sharp focus is 250mm (9.8 inches) from the front of the lens. The 500 and 500D have a focal length of 500mm, so the focusing distance is 500mm (19.75 inches) from the front of the lens. If you set the

prime lens focus closer than infinity, the close-up focusing distance is reduced as well.

Extension Tube EF 25 and EF 12

These close-up devices maintain full electronic coupling between the camera body and the lens, so all functions can be used. The extension tubes EF 25 and EF 12 allow for higher magnifications than are possible with the 250D or 500/500D close-up lenses, and the tubes can also be used in combination with the close-up lenses to obtain still greater magnification.

One or both extension tubes are placed between the EF lens and the camera body to increase the distance between the rear element and the film plane, reducing the minimum-focus distance. Although Canon suggests that best results are obtained with fixed focal length telephoto lenses, our experience shows that nearly any EOS lens can be used with tubes.

In fact, some of our most creative uses of extension tubes are in non-traditional situations, such as placing the EF 12 behind a wide-angle lens, and snuggling the camera under the blooms in a field of wildflowers to achieve a "worm's eye" view. Another approach is to add a tube to the back of a zoom lens and follow a butterfly as it makes its rounds.

Unlike close-up filters, extension tubes cause some light loss, as the lens is distanced from the film plane. TTL metering will automatically compensate for this loss, but if you are using a hand-held light meter or a non-TTL flash, you will need to calculate the exposure increase factor. This exposure factor is determined with the following formula:

$$\text{Exposure} = \left(\frac{\text{Image distance}}{\text{Lens focal length}}\right)^2$$

The resulting number is then applied like a filter factor, so that a factor of two indicates a one-stop increase in exposure is required, a factor of four requires a two-stop increase, etc. Canon recommends manual focusing when using the Extension Tube EF 12

and/or EF 25, although autofocus may work, depending on the lens' maximum aperture.

To simplify extension-factor arithmetic, you may want to consult a close-up exposure calculator, as provided in the *KODAK Professional Photoguide* (R-28) or *KODAK Pocket Photoguide* (AR-21) available from The Saunders Group.

Gelatin Filter Holders

Some filters are too expensive or too infrequently used to justify purchasing a standard optical-glass type. An economical alternative is to buy gelatin filters, which are made of thin plastic. They cost much less than glass filters, and will last a considerable amount of time if handled carefully. Gelatin filters are generally available from several manufacturers in two-, three-, four-, and six-inch squares.

Although Canon is not a supplier of gelatin filters, they do make several adapters to facilitate their use. The Gelatin Filter Holder E is a round ring that screws onto the front of your lens, just as a filter would. It contains a pressure clip to hold up to three circular-cut gelatin filters. Gelatin Filter Holder E is available in 52mm, 58mm, 72mm, and 77mm thread sizes. The 48mm Drop-in Gelatin Filter Holder II is glass-backed, and will accept up to three cut-to-size gelatin filters for all lenses that use 48mm drop-in filters. It is supplied with the EF 200mm f/1.8L USM, the EF 300mm f/2.8L USM, the EF 400mm f/2.8L USM, the EF 500mm f/4.5L USM, and the EF 600mm f/4L USM lenses.

Glossary

The serious photographer can benefit from a basic knowledge of certain optical principles. We have therefore included a glossary of some general lens and optical terminology, and of the nomenclature Canon uses in its technical literature.

Achromatic lens: A lens designed to bring two colors of light into focus at a common point.

Angle of view: The portion of a scene that can be reproduced by the lens. It is expressed in degrees, most commonly measured diagonally across the negative.

Aperture: The opening that controls the amount of light passing through the lens. It is usually constructed as an iris diaphragm consisting of multiple blades, which can be moved to vary the size of the opening.

Aperture priority: A mode of operation that allows the photographer to select the lens opening (f/stop), while the camera automatically selects and sets a shutter speed to give correct exposure. Canon calls this mode Av (Aperture value).

Apochromatic lens: A lens designed to bring all three primary colors of light (red, green, and blue) to focus at a common point.

Arc Form drive (AFD): Canon's term for a brushless motor with a cone-shaped deformation, incorporated into the lens barrel. The AFD motor has a small diameter, and therefore exhibits excellent start/stop response and controllability. The brushless design also contributes to a long service life.

Aspherical lens: A lens having a freely-curved (non-spherical) surface, to correct spherical aberrations. Canon EF lenses make abundant use of ground-and-polished and molded aspherical lens elements.

Astigmatism: A lens aberration that renders an off-axis subject point as an ellipse or line rather than as a point.

Automatic diaphragm: The diaphragm-operating system in most SLR cameras, which keeps the iris open for focusing and composing the image, and closes it at the instant of exposure. Conventional lenses employ mechanical linkages, but Canon EF lenses use electronic connections for more precise control.

Av (Aperture value) mode: See Aperture priority.

BASIS: Base-Stored Image Sensor. Canon's term for a cross-ranging AF sensor, consisting of two 47-bit horizontal-line sensors and two 29-bit vertical-line sensors. BASIS makes autofocusing possible in light levels as low as -1 EV.

Chromatic aberration: An aberration, caused by the lens giving varying degrees of diffraction (bending) to different wavelengths of light. This causes the lens to focus different colors of light at varying distances from the lens.

Circle of confusion: Although light theoretically is focused as a point (an infinitely small dot with zero area), it is actually focused as a dot having a measurable area. Such a dot is called a circle of confusion; the smaller it is, the sharper the image will appear. Canon EF lenses are designed to produce a minimum circle of confusion of 0.035mm, the value on which depth-of-field calculations are based.

Close-up lens: An accessory placed in front of the prime lens to extend its close-focusing range. Sometimes called close-up filters or plus-diopter lenses.

Coma (comatic aberration): A lens aberration. Instead of being rendered as a dot, off-axis images are imaged as a comet shape, complete with a tail. The resulting blur at the edge of the image is called comatic flare.

Contrast: The degree of distinction between light and dark areas in a photograph. In general, high-quality lenses will produce images exhibiting high contrast (as well as high resolution).

Covering power: The circle of even illumination that a lens projects. Normally it is slightly larger than the diagonal measurement of the negative (about 43mm with 35mm negatives), but it needs to be even bigger with lenses that are designed to be displaced, such as Tilt-Shift lenses.

Curvature of field: A lens aberration. When the center of the image is sharp, the edges are not, and vice versa. The field of focus actually is curved, like the inside of a shallow bowl.

Depth of field: The area in front of and behind the plane of focus that will appear acceptably sharp in the photograph. Also referred to as the range or zone of sharpness. In general, depth of field tends to be most extensive with short lenses, small lens apertures, and/or at greater shooting distances; it is shallow with long lenses, large apertures, and/or close distances. About 2/3 of the sharpness zone extends in back of the focused point, and 1/3 in front.

Diffraction: Interference by the edges of the iris diaphragm with the parallel light rays that make up the focused image. This can occur if the diameter of the lens aperture is physically small, as with short lenses at small f/stop settings. Diffraction reduces contrast and resolution, creating a soft-looking image.

Dispersion: Separation of light according to wavelength, accomplished by some media. An example is color separation as light passes through a prism.

Distortion: This lens aberration affects the way shapes are recorded on film. With barrel distortion, vertical lines at the edge of the image bow out; with pincushion distortion, the lines bend in.

EF lens mount: The fully electronic lens mount developed by Canon for EOS cameras. All information is transmitted electronically between the camera and lens (maximum aperture, selected aperture, focal length, etc.), eliminating the need for mechanical levers or cams.

Flare: Light reflected from the interior surfaces of the lens and/or the mirror box, which can reach the film and degrade the image. This problem is greatly reduced by proper lens design, anti-reflection treatment of the mirror box and lens barrel, and coating of lens surfaces. The use of an appropriate lens hood also helps prevent flare.

Fluorite: An optical material with extremely low indices of refraction and dispersion, compared to optical glass; and virtually ideal correction of chromatic aberrations, when combined with optical glass. Canon was the first camera manufacturer to utilize fluorite in photographic lenses.

Focal length: The distance along the optical axis from a lens' optical center to the film plane, with the lens focused at infinity. The focal length controls the size of the on-film image and the angle of view, and also affects depth of field.

Focus preset: A focusing function offered by several of Canon's super telephoto lenses. It allows the photographer to set a focus distance that can be recalled by the lens instantaneously. Normal focus operation is not affected. See also, page 80.

Ghost images: A type of flare caused by the sun or other bright light source in the picture area, creating a series of reflections within the lens. These can be seen if the camera's depth-of-field preview is used prior to shooting the picture.

Lens aberrations: Anomalies in lens performance. Even with modern computer design, exotic glasses, and aspherical elements, it is still impossible for a lens to achieve perfection. The common lens aberrations are: spherical aberration, coma (comatic aberration), astigmatism, curvature of field, distortion, and chromatic aberration.

Lens speed: Refers to the maximum (largest) aperture of a given lens. Fast lenses have a large aperture and, in general, are physically much larger and demand a higher price, slower lenses are smaller, weigh less and cost less. For example, the EF 300mm f/2.8L USM is faster than the EF 300mm f/4L USM. The focal length

is the same but the maximum aperture is one stop "slower" on the f/4 version.

Optical axis: The theoretical center line of a lens, connecting the center points of the spherical surfaces of each lens element. Practically speaking, the axis is the direction in which the lens is pointing.

Optical glass: Glass specially made for use in precision optical products, such as photographic lenses and microscopes. Optical glass has fixed, precise refraction and dispersion characteristics.

Rear focus: Innovative lens design that requires only the rear element group(s) to move during focusing. This has allowed Canon to reduce the size and weight of their lenses and increase the AF speed. Also, front elements do not rotate and the lens size doesn't change for easier handling.

Resolution: The ability of a lens to reproduce a point on the subject as a point on the film. The sharpness of the final image is affected by the resolution of the entire photographic system, including the camera lens, the film, the enlarger lens and the printing paper.

Retrofocus lens: A short focal-length (wide-angle) lens that is physically longer than its effective focal length. If not designed this way, the lens would fit so far into the SLR camera body that it would interfere with the movement of the reflex mirror. Most current wide-angle lenses for SLR cameras use retrofocus designs.

Selective focus: Utilizing shallow depth of field to isolate a sharp subject against an out-of-focus background, creating a strong center of interest.

Shutter priority: A mode of operation that allows the photographer to set the shutter, and the camera to select a corresponding aperture. Canon calls this mode Tv (Time value).

Spherical aberration: A lens aberration caused by the fact that light entering the lens at the edge must be refracted (bent) more than light entering nearer the center.

Tele-extender: An optical accessory (also called a teleconverter) that fits between a lens and the camera body, increasing the effective focal length of the lens. Canon supplies tele-extenders that increase focal length by a factor of 1.4x or 2x.

TTL (Through-the-Lens) metering: A system that determines exposure or light values by measuring the light passing through the lens into the camera. TTL meters may read ambient light or the light from a dedicated flash unit.

Tv (Time value) mode: See Shutter priority.

UD glass: A special glass, possessing optical characteristics similar to fluorite. In Canon parlance, UD stands for ultra-low dispersion. UD lens elements are particularly useful in correcting chromatic aberrations in super-telephoto lenses.

Ultrasonic Motor (USM): A focusing motor invented by Canon, and incorporated in many EF lenses. The USM is quieter and quicker than conventional AF motors.

Vignetting: Light falloff, or darkening, at the edges of the image. This can be caused by the lens design, or by the use of an inappropriate lens shade or hood. Stacking more than one filter on the front of a lens, or using a filter that is too thick, can also cause vignetting.

Magic Lantern Guides

....take you beyond the camera's instruction manual.

The world's most popular camera guides; available for most popular cameras.

From Hove Books

Canon Compendium
Written by Bob Shell, editor of *Shutterbug Magazine* and authority on the Canon system. This superbly-illustrated guide features 230 photos of Canon equipment, including early rangefinder cameras, lenses of various generations, etc. It also features a guide to the complete EOS system with information on equipment compatibility, detailed equipment charts and a comprehensive index. Hardbound. 200 pages.

Notes

Notes